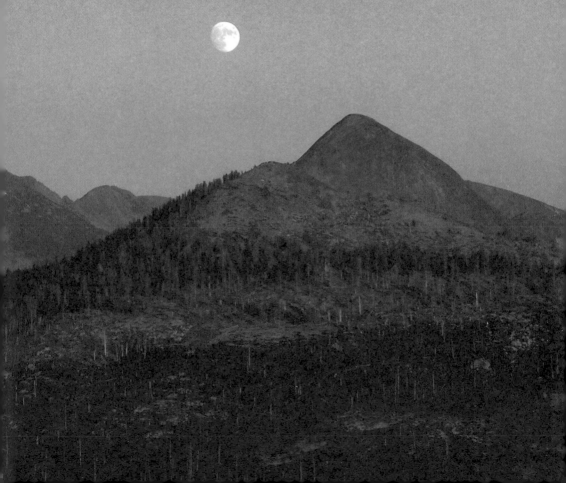

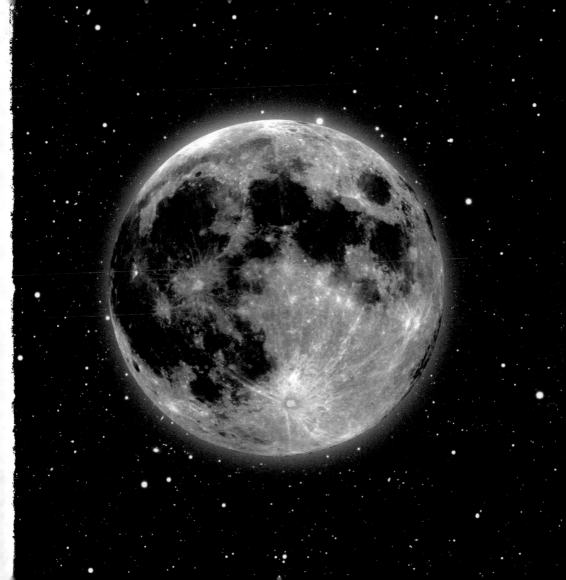

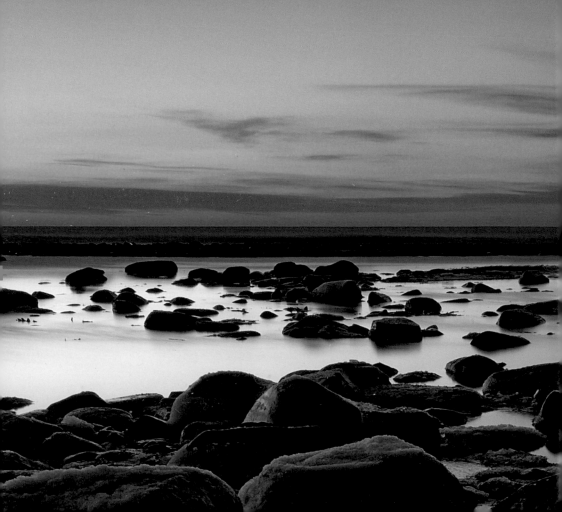

the moon

Michael Carlowicz Abrams, New York

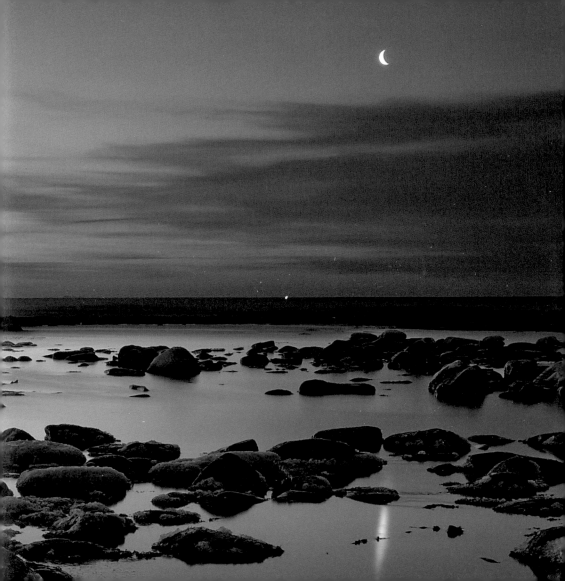

For Mom and Dad—*"Bang! Zoom! Right to the Moon, Alice . . ."*

Contents

Fly Me to the Moon

The book of moonlight is not written yet.

Wallace Stevens

That's no travel coffee mug. Astronaut Alan Bean holds a vessel for collecting lunar soil while Charles "Pete" Conrad snaps his photo during the Apollo 12 mission in November 1969. Conrad and the stark Oceanus Procellarum (Ocean of Storms) are reflected in Bean's visor.

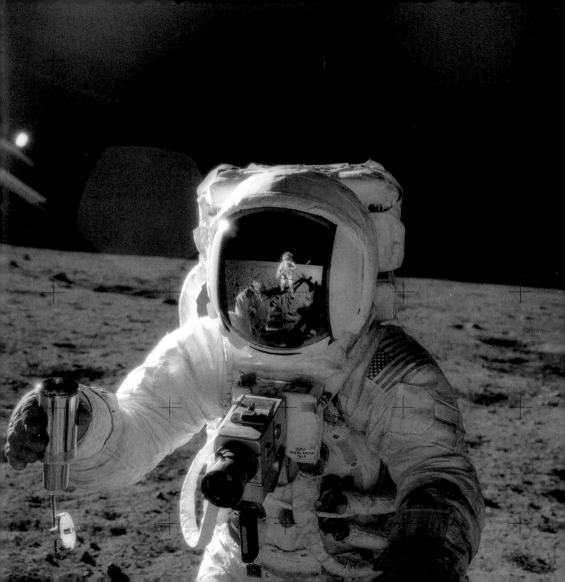

SILVER AND SWOLLEN, THE MOON LOOMS OVER OUR LIVES. AS
Earth's closest celestial neighbor, the natural satellite sometimes called Luna
draws our eyes and our minds as much as it tugs on our tidal seas. It is the
centerpiece of myths, monuments, and religions; a presence and influence on
Earth's natural and astronomical order; a muse to writers and artists; and a
target for the telescope-pointing astronomer and the rocket-steering astronaut.
The Moon is seemingly colorless and constant, and yet it takes on many differ-
ent faces and roles in the stories of our lives.

The Moon is the dominant timekeeper for humans (surpassing even the
Sun), as it marks the passage of days and months and seasons. Ancient
cultures from Mesopotamia to Arctic tribes built their calendars and customs
around the lunar cycles, and though most modern believers have dropped the
Moon deities, they cannot shed the lunar connections and influences. Muslims,
Jews, and Christians all look to the Moon to set their holy calendars, and the
traditional Chinese calendar still uses a lunar source to determine the day of
the New Year and the Autumn (Moon-Cake) Festival.

Do you ever wonder what the Moon is made of? Some have said it is fresh
green cheese, others claim it is primordial rock left over from the dawn of our
solar system. The predominant view today is that it is made of basalt that was
splashed out of Earth after a cataclysmic collision. The story of the Moon's
composition and origins is still being teased out by scientists who study the
only rocks humans have ever collected from another celestial body.

The Moon has long been a destination in the human mind—a place we
yearned to visit long before we knew what was over the next horizon or
across the wide oceans. Writers and scientific thinkers have been trying to
get us there for at least 500 years. The *New York Sun* newspaper infamously

took many for a (moon) ride in 1835 when it published a series of sensational articles about lunar animals, oceans, and human-like creatures "discovered" by powerful new telescopes. Thirty years later, Jules Verne took readers to the Moon, though he stayed comfortably within the confines of science fiction.

Then, the fiction became reality. From 1957 to 2006, forty-eight unmanned and manned spacecraft successfully crossed the gulf between the Earth and Moon. Nearly a billion of us watched or listened to the first radio and television transmissions from another world, and many of us can recall where we were on that day in July 1969 when Neil Armstrong made one small step for us all. In the not-so-distant future, the Moon will change from destination to waypoint, as we stride farther into the solar system to consider the views from moons of Jupiter, Saturn, Neptune, or a planet in some other solar system.

We shall take the Moon with us, as we always have. It follows us when we venture outside at night, and has long been the guiding light for lovers, hunters, lunatics, and refugees. We all have a Moon that speaks to us—the crescent, the quarter, the full—and nearly all of us project some form onto that face, be it a man, a woman, a rabbit, or a god. The Moon is very much a part of us; we are connected to it and, in turn, to each other.

Two moons of Saturn, Mimas and Enceladus, show their light and dark sides when viewed across the planet's rings. Mimas makes a dark, shadowy dot as the Cassini spacecraft observes it on the near side of the rings, backlit by the Sun; Enceladus is on the far side, lit by Saturnshine, the sunlight reflecting off the planet.

→ The surface of Jupiter's moon Io is covered in a frost of sulfur and sulfur dioxide, which is spewed as far as 500 kilometers (more than 300 miles) into the atmosphere. Io is dotted with hundreds of volcanoes, lava lakes, and mountain peaks, the tallest of which is nearly 16 kilometers (52,000 feet).

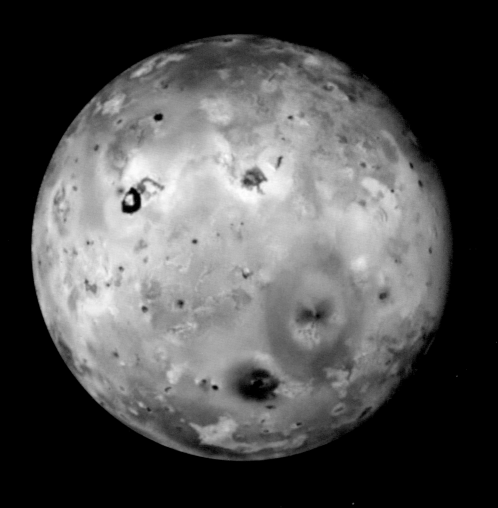

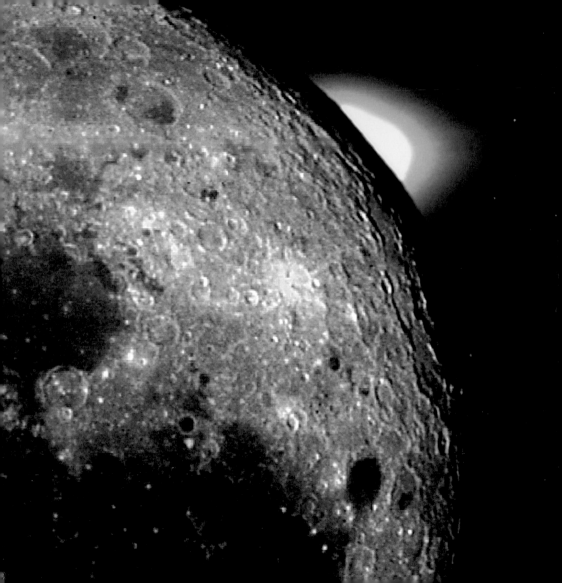

↑↑ The Sun's corona, or atmosphere, and the planet Venus (upper right), are visible over the limb of the Moon. The lunar disk is lit by reflected sunlight from Earth.

↑ Haze and gas in the atmosphere of Titan, the best-known moon of Saturn, conceal a surface that some researchers believe has the potential for sheltering life.

13

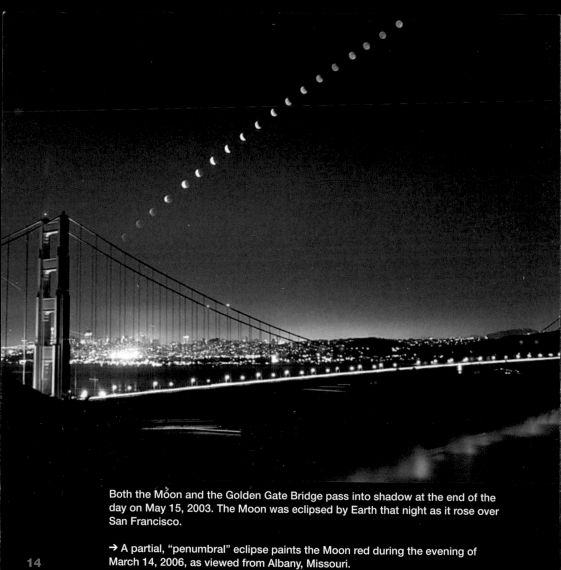

Both the Moon and the Golden Gate Bridge pass into shadow at the end of the day on May 15, 2003. The Moon was eclipsed by Earth that night as it rose over San Francisco.

→ A partial, "penumbral" eclipse paints the Moon red during the evening of March 14, 2006, as viewed from Albany, Missouri.

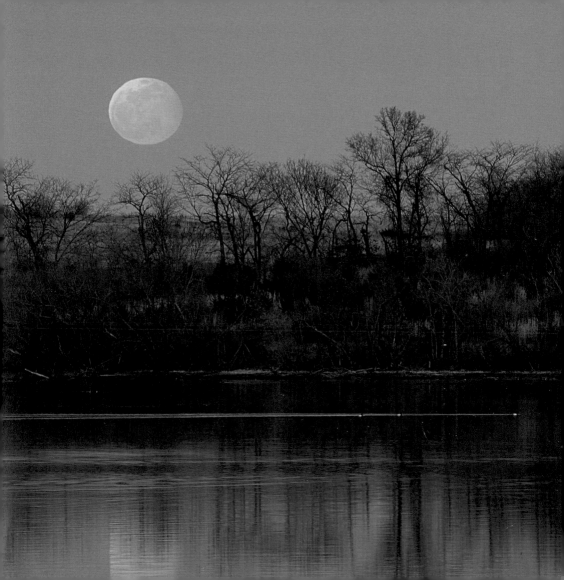

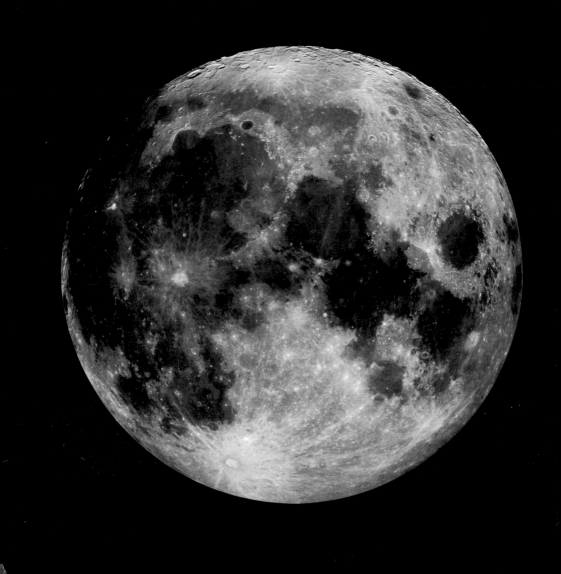

The Moon appears to have a corona—or extended atmosphere—as its light passes through ice crystals and clouds in Earth's atmosphere.

← The *Galileo* spacecraft snapped this image of the Moon in 1992 as the vehicle made its way toward Jupiter. The bright crater at the bottom of the image is the Tycho impact basin; the dark areas are lava-filled impact basins—Oceanus Procellarum (left), Mare Imbrium (center left), Mare Serenitatis and Mare Tranquillitatis (center), and Mare Crisium (right edge).

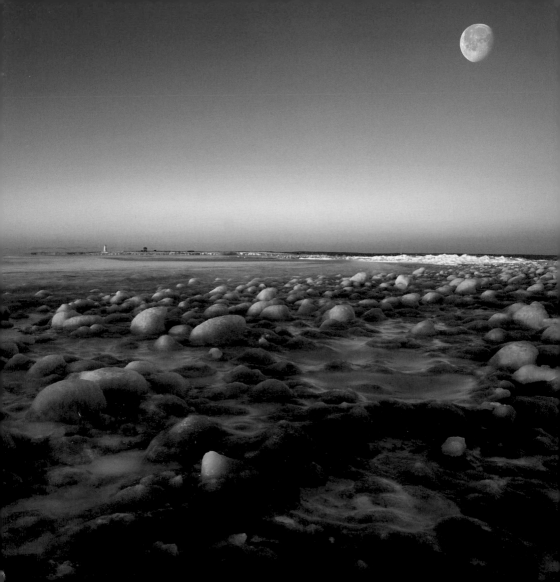

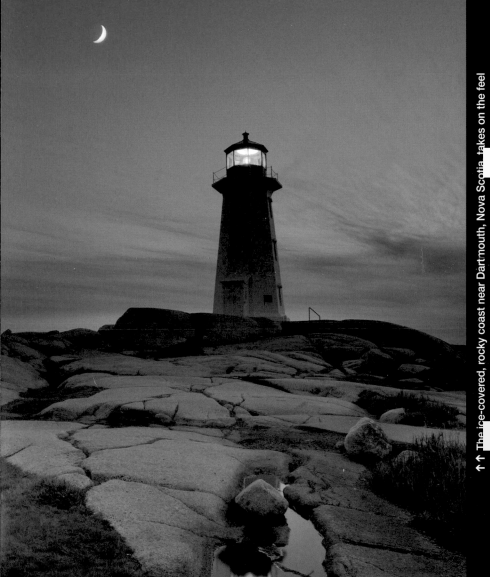

↑↑ The ice-covered, rocky coast near Dartmouth, Nova Scotia, takes on the feel of a [...] landscape in the light of dawn and the waning gib[...] Moon.

↑ The lighthouse at Peggy's Cove, Nova Scotia, mimics the crescent light of the Moon after sunset.

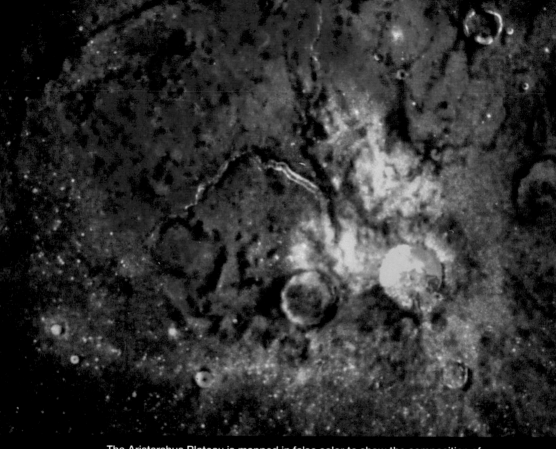

The Aristarchus Plateau is mapped in false color to show the composition of
the materials at the surface—and to show hints of the Moon's geologic past.
Deep reds are volcanic ash deposits, yellows are outcrops of fresh basalt, and
reddish-purples are lava flows.

→ The planet Neptune rises in the skies above Triton, one of the planet's 13
moons. This composite view blends a Voyager image of the planet with a
computer-generated projection of the moon's surface.

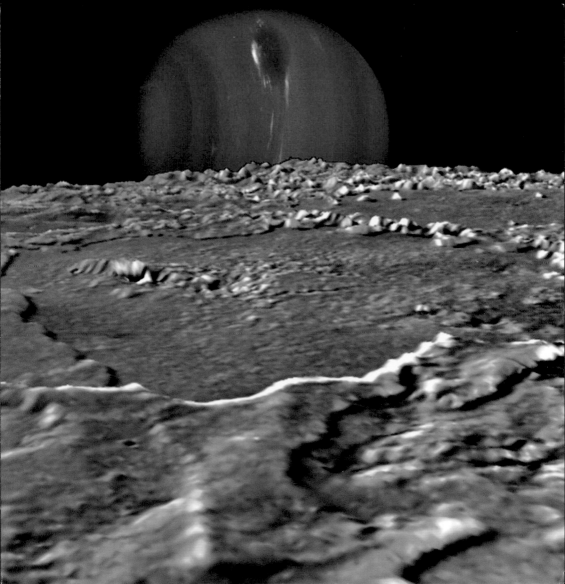

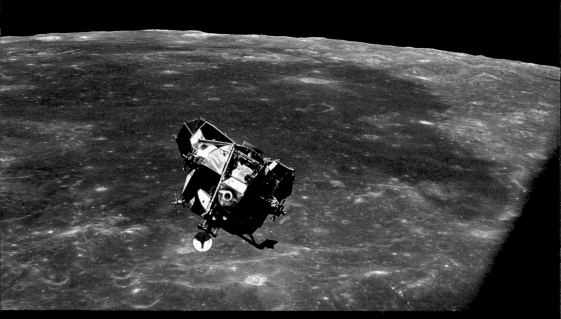

Astronaut Michael Collins captured this view of the *Eagle*—the Apollo 11 lunar module—bringing his fellow explorers Neil Armstrong and Buzz Aldrin back to the orbiting command module after the first lunar landing mission in 1969. Earth looms over the Moon's horizon.

→ Space shuttle *Atlantis* rolls out to Launch Pad 39A in the light of the Moon. After the Apollo days, the Earth-orbiting shuttle kept alive the dream of space flight but not of human exploration of the solar system.

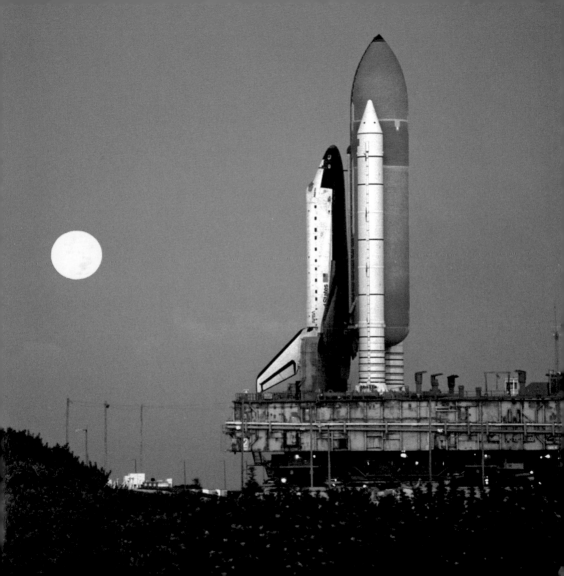

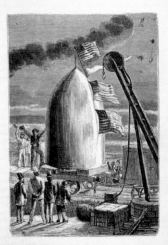

THE ARRIVAL OF THE PROJECTILE AT STONE'S HILL.

[p. 122.]

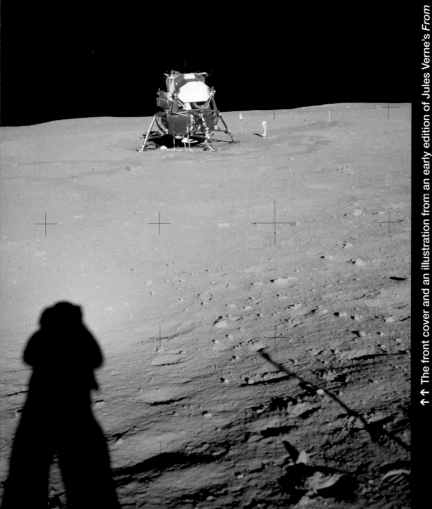

↑ The front cover and an illustration from an early edition of Jules Verne's *From the Earth to the Moon* depicts the "projectile-vehicle" *Columbiad*, a spaceship built by the fictional Gun Club of Baltimore to take its passengers to the Moon.

↑ When astronauts took photos facing away from the Sun, they sometimes spied haloes around their heads. This "opposition effect" results from sunlight reflecting directly off of the fine powder of the lunar surface, which mysteriously stands in microscopic towers that hide their own shadows and spread more light. (See also pages 89 and 90.)

Night Light

And all the night's magic seems to
 whisper and hush,
and all the soft moonlight seems to
 shine in your blush.

Van Morrison, "Moondance"

Oyster farmers on Cape Cod harvest their crop by the light of the full "Long Nights" Moon (December). They work at night because they can harvest their shellfish only at low tide.

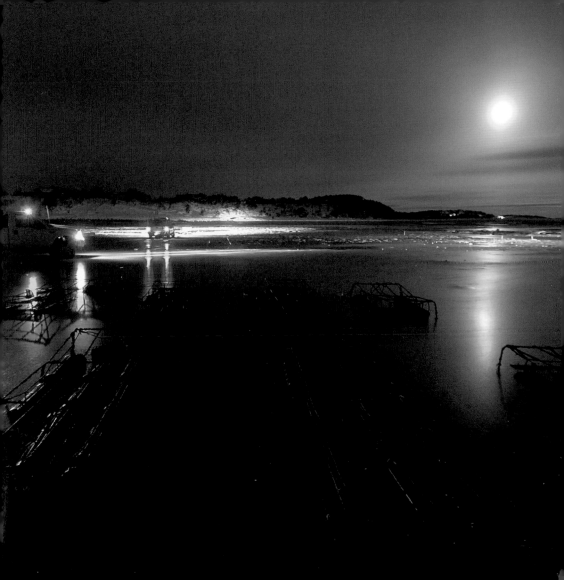

MAYBE IT'S BECAUSE IT IS THE SECOND BRIGHTEST OBJECT IN our sky, yet the first one we can view with unaided eyes. Maybe it is because we can gaze at its features as long as we like, while we cannot look at the Sun long enough or the planets closely enough to distinguish much. Maybe it is because it is close enough to beckon us to visit, yet far enough to tell us it would be a grand adventure. Whatever it is, the Moon calls to us and influences the workings of our planet.

The Moon is 384,000 kilometers (238,000 miles) away, a shorter distance than many of us will travel by car, boat, and air in our lifetime. It is a quarter of the size of our planet, the largest ratio of a satellite to its mother planet in our solar system. To an extraterrestrial exploring our solar system, the Earth-Moon system might be mistaken for a double planet.

Earth's natural satellite is 100 times closer than our nearest neighbor, Venus, and 400 times closer than the Sun. With proximity comes influence, the most obvious physical effect being the daily rise and fall of the tides. The Moon exerts a gravitational tug on the near side of Earth and the water on that side, drawing it higher out of its basins. It simultaneously pulls on the solid center of Earth, so that the planet sort of stretches toward the Moon and away from the water on its far side.

The Sun has a far stronger gravitational field, but it exerts much less tidal force because it is so much farther away than the moon. The Sun and Moon spend half of each month working together—lining up with Earth to create the "spring" tides around the full and new Moons—and work against each other—pulling at different angles to make the "neap" tides of the first and last quarters. If there were no Moon, we'd still have tides (caused by the Sun), but they would be one-third of what we're familiar with today.

Some regions of the world are now being powered by the Moon, in a roundabout way. Tidal power generators—underwater turbines spun by tidal currents—are already at work in France, Russia, China, and Canada, with installations being considered in half a dozen other countries.

Of course the lunar energy that is more familiar to most of us is its light (which, of course, is actually the reflected rays of the Sun). Long before the torch and the light bulb, the Moon was the original, free night light, providing just enough illumination to see the creatures of the night and to light the way to the watering hole or home cave. Full moonlight at harvest time has long allowed farmers to continue gathering their crops despite waning daylight hours. Slaves and refugees used this celestial light to find the path to freedom on the "Underground Railroad."

Moonshiners can get just enough light to conduct their nefarious alcohol-distilling under cover of night. And though electric lights have turned night into day almost everywhere in the world, we still say someone is "moonlighting" when they take an extra job—or lover—after their daytime duties are done.

Besides separating night from day (which it does imprecisely, since it is often visible in daylight), the Moon is a master timekeeper. From the beginning of recorded human history, even from ancient cave paintings and relics of the Stone Age, humans have relied on the lunar cycle as the basis for a calendar. The very word *month* seems to be loosely related to the words *Moon* and *menes* (origin of menstrual).

The cycle of roughly 29.5 days—709 hours—between new moons is called the synodic month. This marks the amount of time it takes for the Moon to return to the same orbital position relative to the Sun, as viewed from the Earth. The Moon also moves through sidereal months—27.3 days—which is

the amount of time it takes for the Moon to return to the same position on the celestial sphere of fixed stars. This is why many ancient cultures in the Middle East and Asia referred to the twenty-seven or twenty-eight "mansions of the moon," referring to its different homes in the sky throughout the month.

"He appointed the moon for seasons," the prophet wrote in Psalm 104, and certainly each full moon ushers in a different sort of natural and human activity. Native American Indian tribes (the Algonquians are often credited) gave names to each of the full Moons based on what they could eat, hunt, harvest, or expect out of the lunar cycles across the year. Those names were gradually adopted and adapted by European settlers in the Americas.

The Wolf Moon comes each January with the howling, hungry canine, followed by the Snow, Worm, Pink, and Flower moons as we progress into spring. With the first crops in June comes the Strawberry Moon, then the Buck and Sturgeon moons. September brings the Harvest Moon, along with its work in the fields and its festivals. The Hunter's Moon, or Blood Moon, was so named because it made it easier to sight and track the fattened prey of late autumn. The Beaver Moon and Cold Moon usher in another season of hunkering down out of the elements.

It was partly out of this tradition that we arrived at our modern—and incorrect—definition of a "Blue Moon" as the second full Moon within a calendar month. The error allegedly began in 1946 when a writer incorrectly described the Blue Moon phenomenon in the popular *Sky & Telescope* magazine. According to the nineteenth-century *Maine Farmers Almanac*, the Blue Moon was the third full moon in a tropical quarter (or season) of the year that had four full moons. The extra Blue Moon was inserted to keep the rest of the moon-naming conventions (Harvest, Hunter's, Wolf) on schedule. But when a writer

tried to explain the quirk of thirteen moons in a calendar year, he botched the explanation and set up the idea of two full moons in a civil calendar month. (By that definition, you could have Blue Moons in some locations of the world and not others because of different time zones.) *Sky & Telescope* recently ran a correction to get everyone back on track, but there is no getting rid of the idea now that it is in common parlance.

Ironically, it is actually possible to spy a blue-colored Moon. When there is enough smoke or dust in the atmosphere—such as when there have been extensive wildfires or volcanic eruptions—the face of the Moon can appear blue. The eruption of Krakatoa in 1883 made the Moon blue for nearly two years. Such events are exceedingly rare, of course, providing us with the underpinning of the colloquial phrase "once in a Blue Moon."

↑↑ A satellite view of the Minas Basin in Canada's Bay of Fundy reveals the extreme differences between high (above) and low tide (below) in the region. High tide can be as much as 17 meters (56 feet) higher than low tide.

↑ A sailboat near Wolfville, Nova Scotia—along the Bay of Fundy—floats and beaches daily with the tides. The combination of solar and lunar gravity and the [...] like topography of the region create perfect conditions [...] reme tides.

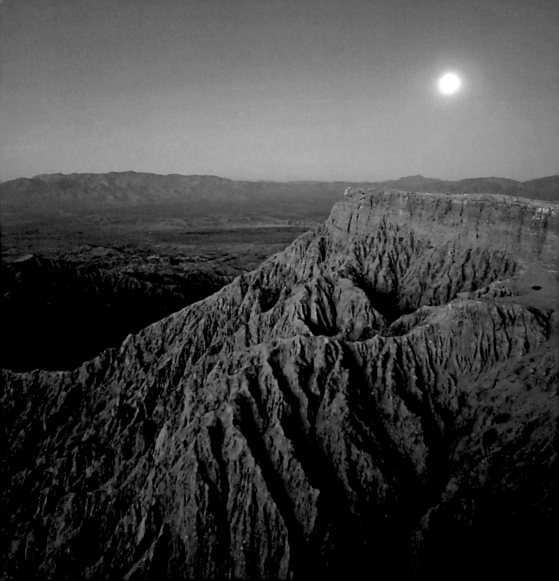

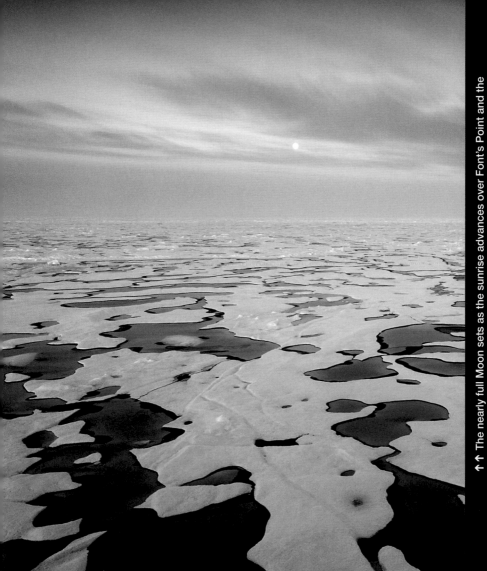

↑↑ The nearly full Moon sets as the sunrise advances over Font's Point and the Borrego Badlands in Southern California's Anza-Borrego Desert.

↑ In late August, the sun is finally low enough in the sky to allow a view of moonrise over the Beaufort Sea, north of Alaska.

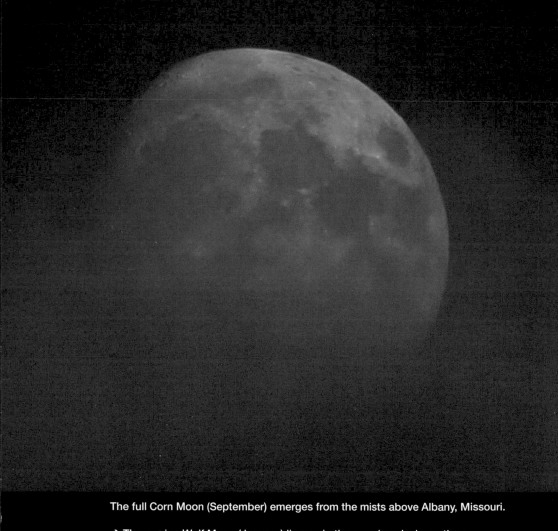

The full Corn Moon (September) emerges from the mists above Albany, Missouri.

→ The waning Wolf Moon (January) lingers in the morning sky in northern Missouri.

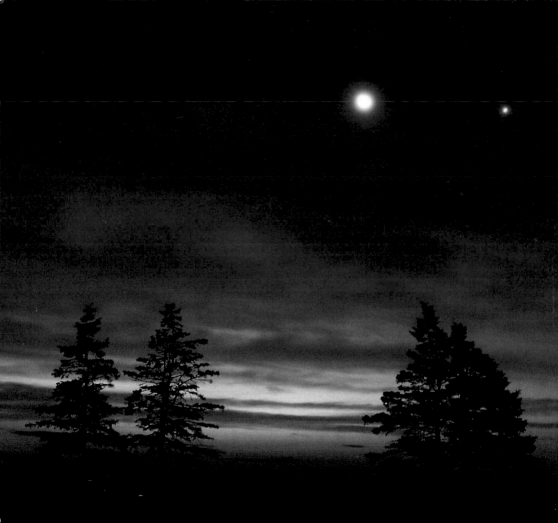

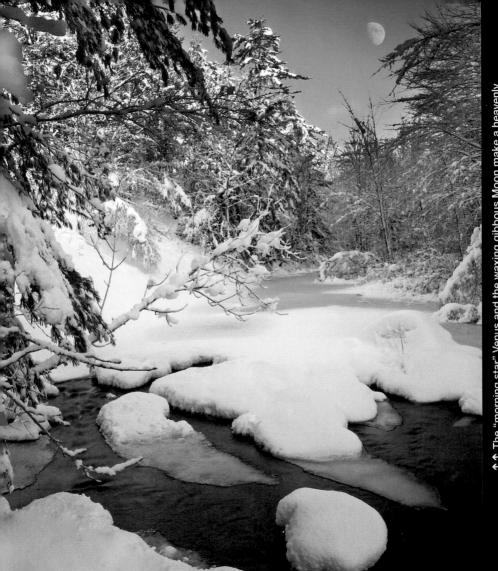

↑ ↑ The "morning star" Venus and the waxing gibbous Moon make a heavenly couple awaiting sunrise near Gore, Nova Scotia.

↑ Snowfall greets the waxing gibbous Moon near Lantz, Nova Scotia.

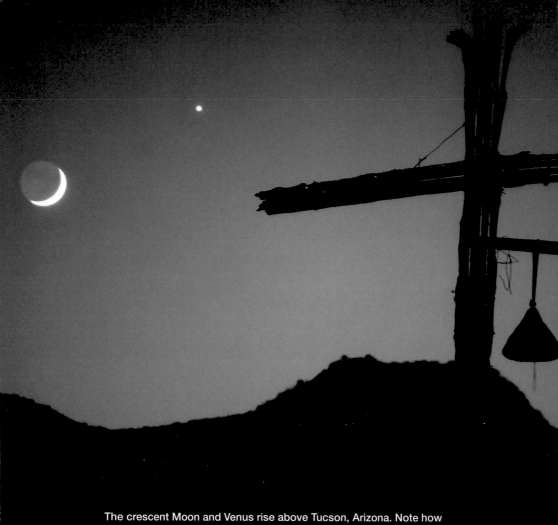

The crescent Moon and Venus rise above Tucson, Arizona. Note how earthshine—the reflected light of Earth—brightens the remainder of the Moon alongside the Sun-lit crescent.

The waning crescent Moon lights a tree in a field near Zwingle, Iowa.

41

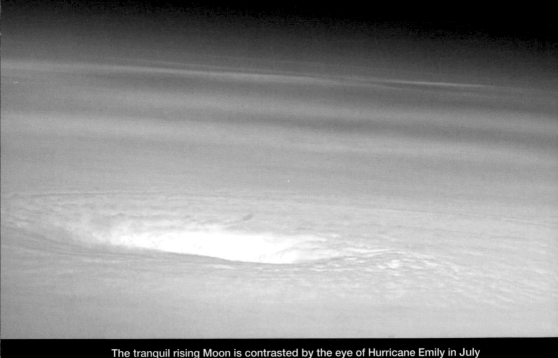

The tranquil rising Moon is contrasted by the eye of Hurricane Emily in July 2005. The Moon has no atmosphere, nor does it affect weather on Earth. But the phase of the Moon can influence the size and timing of tides, an important factor in the height of coastal storm surges from approaching hurricanes.

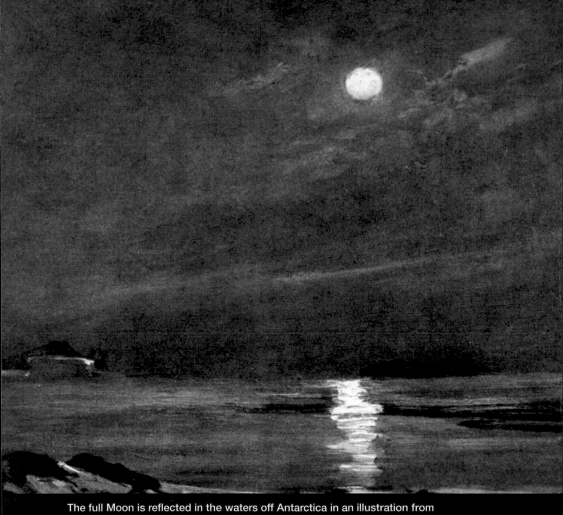

The full Moon is reflected in the waters off Antarctica in an illustration from Ernest Shackleton's 1909 book *The Heart of the Antarctic*.

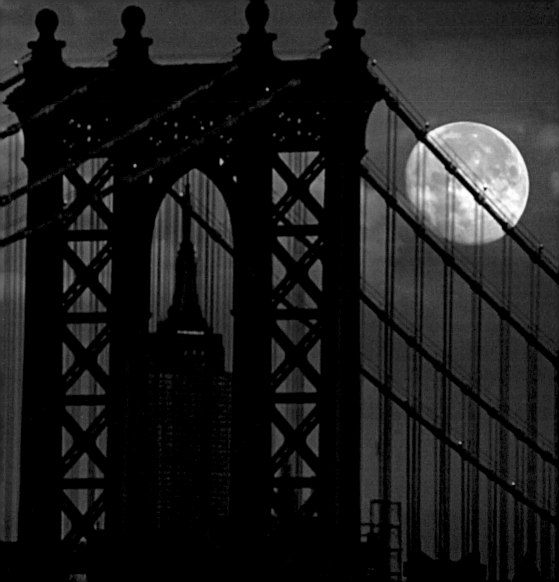

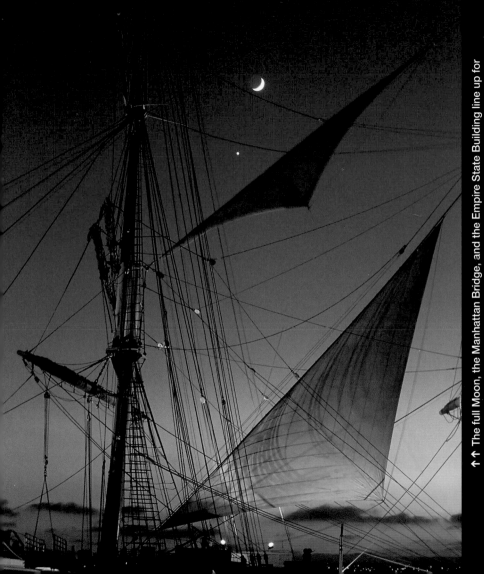

↑↑ The full Moon, the Manhattan Bridge, and the Empire State Building line up for a grand New York City portrait.

↑ The crescent Moon and the planet Venus chart a course for the tall ship *Star of India*, docked near Harbor Drive in San Diego, California.

Queen of the Night

It is the very error of the moon;
She comes more near the earth than she
 was wont,
And makes men mad.

Shakespeare, *Othello*

The Moon—controlled in Greek mythology by the goddess Selene—rises over the Temple of Poseidon in Sounio, Greece. Selene was daughter of the titans Hyperion and Theia, and sister to the sun god Helios. Scientists have applied her name to the study of the geology of the Moon—selenology.

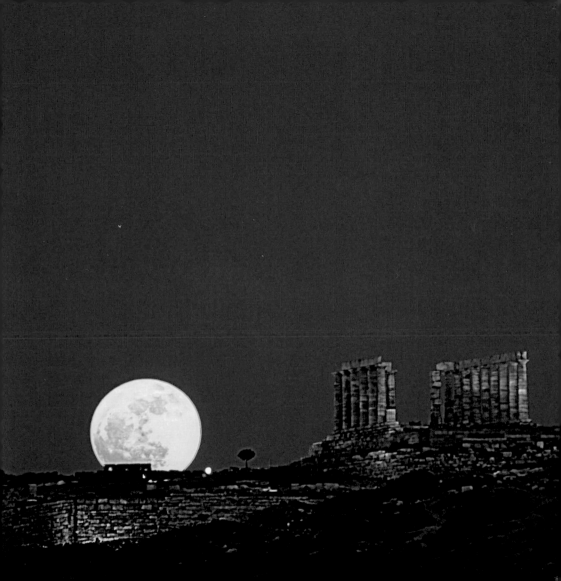

FOR AS LONG AS WE HAVE BEEN LOOKING TOWARD THE SKIES,
the Moon and Sun have dominated not only our religious symbols and art, but also our understanding of ourselves. Whether as an active deity or a portent of divine will and intervention, the Moon has been believed to influence earthly events. Certainly it awes us and inspires us.

The gender and roles of the Moon have changed through the centuries and from tradition to tradition. In ancient Egypt, the ibis-headed male god Djehuty (also known as Thoth) was linked to the Moon as master of the night skies, measurer of time, creator of the calendar, and arbiter of souls. In one myth, Thoth is said to have gambled with the moon god Khonsu for five days of moonlight.

In Mesopotamia, the cradle of civilization, the Sumerians paid homage to the male moon god Nanna, whose name meant "illuminator." Nanna was called Sin by the Babylonians and Akkadians. Sin was the leader or father of the gods, and held a special place in the hearts of nomads, who needed his moonlight to guide and protect them at night.

The Greeks made sacrifices to the female goddess Selene, the Romans to Luna. Each was the personification of the Moon, and each followed her sun-god brother across the sky. Luna and Selene were known for their fertility and love affairs, and both were eventually supplanted by Phoebe and Artemis (Greece) and Diana (Rome), who kept the lunar symbols as well as the feminine connections to fertility and childbirth.

In ancient Chinese mythology, three fairies took on the likeness of old beggars and asked a fox, monkey, and rabbit for food. The fox and monkey had food to share, but the rabbit did not, so he offered himself up as food and jumped in the fire to be cooked. The fairies were so moved as to let him live in

the Moon Palace, giving us the "rabbit in the moon" instead of the "man" that other cultures see.

The Inuit people told a story of Anningan, the moon god who chases his sister, the sun goddess Malina, across the sky. Anningan forgets to eat while he is making his chase, which is why he grows thinner. He then disappears for a few days (around the new Moon), to fill up and resume the chase.

Though monotheism has replaced the pantheons and Moon worship in many parts of the world, the old lunar symbols and connections persist in those religions. The Jewish calendar is built on lunar months, and the Muslim holy month of Ramadan begins with the first sighting of a crescent Moon. The Virgin Mary is often shown standing on a crescent Moon to symbolize her status as queen of the universe. Mary, like the Moon, reflects the light of her Son/Sun. Some have claimed that she supplanted many of the moon-mother goddesses of ancient religions.

Not everyone accepts the Moon as god or goddess, but some still look to it as a muse. Hundreds of storytellers have brought us to the Moon or brought the Moon to us, from Lucian to Jules Verne, from William Blake to H. G. Wells, from Arthur C. Clarke to Margaret Wise Brown. Wolf-man or werewolf stories were handed down in oral and written traditions for hundreds of years, but it apparently wasn't until the nineteenth century that fiction writers linked lycanthropy with the full Moon.

Many musicians and lyricists have brought the power of moonlight to our ears, telling tales of love and unrequited love, of madness and monsters, of nostalgia and sentiment. Debussy gave us "Au Clair de Lune" (By the Light of the Moon) and Beethoven the "Moonlight Sonata." Nat King Cole sang to us that "It's only a paper moon, hanging over a cardboard sea," while Pink

Floyd said they would "see you on the dark side of the Moon." We've heard about the "Bad Moon Rising," the "Blue Moon" that saw us standing alone, the "Moon River, wider than a mile" and that "giant steps are what you take, walking on the Moon." Frank Sinatra and conductor Nelson Riddle dedicated an entire 1966 album—"Moonlight Sinatra"—to our nearest celestial neighbor.

The Moon has inspired the coinage of words and names. The term *honeymoon* is allegedly derived from an ironic comparison of love and marriage to the waxing and waning of the Moon's phases. There is also reference to a medieval custom whereby newlyweds were supposed to drink mead—a honey-based alcohol—exclusively during the first month of marriage, when marriage was thought to be sweetest before, like the Moon, it began to wane.

The luna moth, moon fish, and moon jelly all suggest lunar reflections in their colors and shapes, as does the act of "mooning" your unsuspecting friends and disrespected enemies. The word *lunatic*—"affected with periodic insanity, dependent on the changes of the Moon"—conjures a higher lunar power over human behavior.

The Moon has even shown up in our social and biological sciences, not to mention pop psychology. For centuries, our folklore, superstitions, and anecdotal experiences have linked the Moon—most often the full Moon—to human activities both natural and unnatural.

Some have argued that more crimes are committed, more accidents occur, and more suicides take place around the time of the full Moon. Hospital emergency rooms, baby-delivery rooms, and psychiatric wards are said to be hopping with activity when the Moon is in full bloom. Others have postulated that the Moon affects the weather and the climate, not to mention the occurrence of natural disasters. Some stock traders will tell you that returns are generally

lower around the full Moon than they are at the new Moon. My mother is one of many people who insist that the full Moon can make her joints ache or cause other maladies.

Both serious researchers and laughable quacks have compiled data on the popular lunar myths and anecdotes in more than a hundred different scientific studies. Taken together, the studies reveal some occasional correlations, but little reliable evidence of a lunar effect beyond self-fulfilling prophecy and coincidence. And no one seems to be able to offer testable physical or physiological hypotheses for why the Moon should give us anything more than a night light and tides.

But that doesn't stop most of us from believing. It is convenient, it's fun, and it's instinctive to accept the power of the Moon.

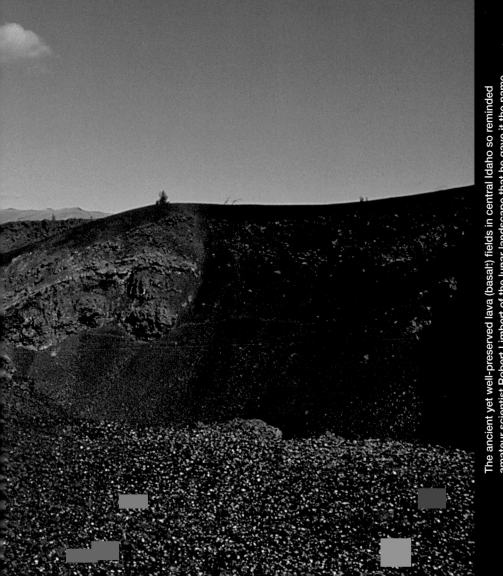

The ancient yet well-preserved lava (basalt) fields in central Idaho so reminded amateur scientist Robert Limbert of the lunar landscape that he gave it the name "Crater of the Moon" in a 1924 article for *National Geographic*. The area is now a

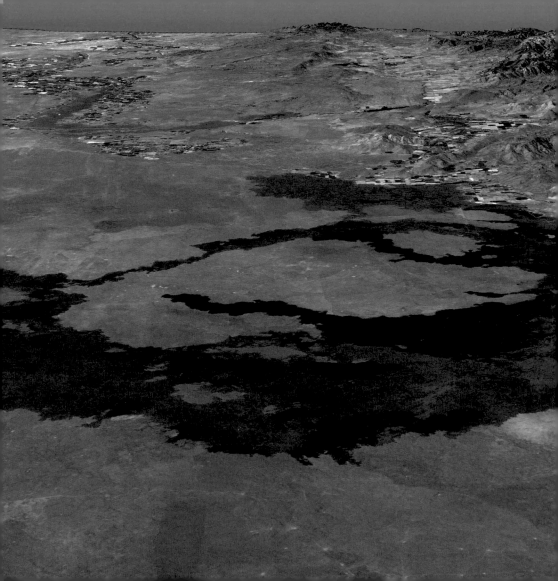

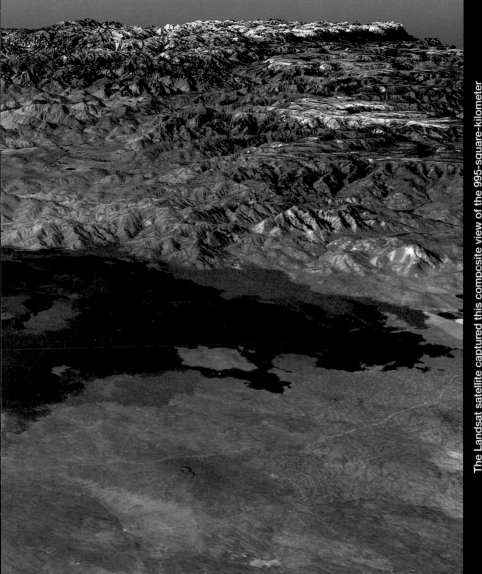

The Landsat satellite captured this composite view of the 995-square-kilometer (618-square-mile) plateau around Craters of the Moon National Monument in Idaho. NASA sent three Apollo astronauts to train for lunar exploration in this area where lava once poured from ancient volcanoes. Appropriately enough, the lava field is crescent shaped.

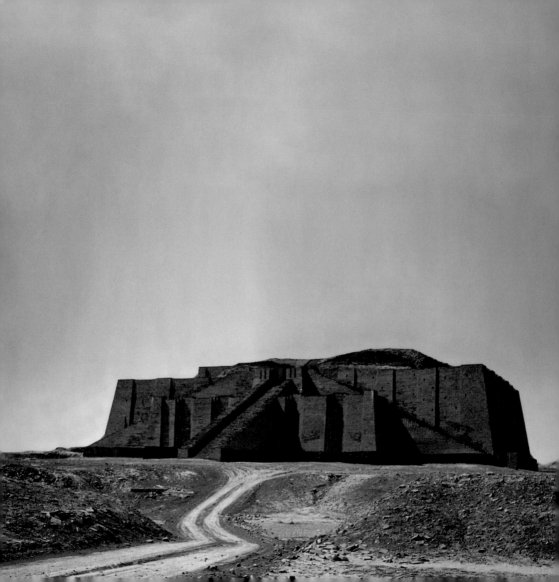

↑↑ The ancient city of Ur is home to the Ziggurat of Nanna, a temple to the Sumerian moon god Nanna and the Babylonian moon god Sin. It was built around 2100 BC.

↑ The crescent Moon and star are often cited as the symbol of Islam. Legend holds that the symbol was adopted when Osman, Islamic founder of the Ottoman Empire, conquered Byzantium and adopted that city's symbol. Muslims use a lunar calendar, with the holy month of Ramadan beginning at the first sighting of the crescent Moon.

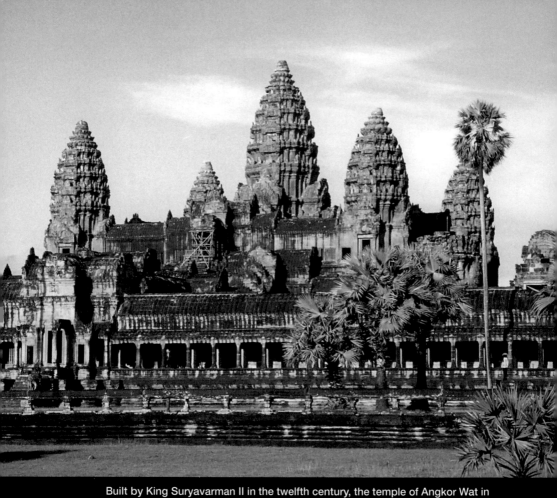

Built by King Suryavarman II in the twelfth century, the temple of Angkor Wat in Cambodia includes several connections to the lunar cycle. In Hindu cosmology, the Moon has 27 or 28 "lunar mansions" for each of its different paths through the sky—and its background of stars—in a lunar month. The towers and libraries within the temple have dimensions that play off this number.

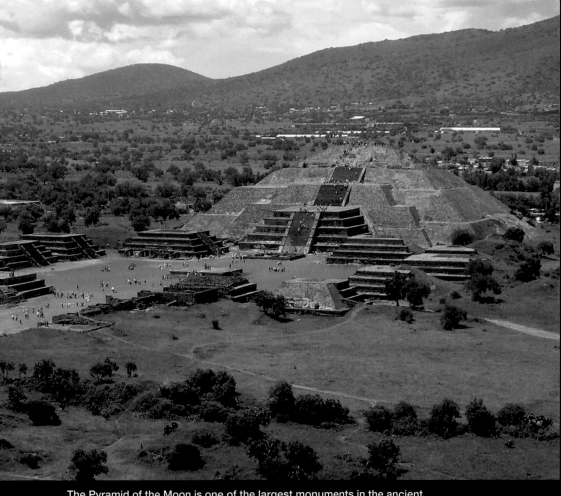

The Pyramid of the Moon is one of the largest monuments in the ancient Mexican city of Teotihuacán. Built around 200–250 AD, the apex of the pyramid coincides with the notch on the top of Cerro Gordo, the mountain to its north, as viewed from the Avenue of the Dead, the road leading up to the pyramids' steps.

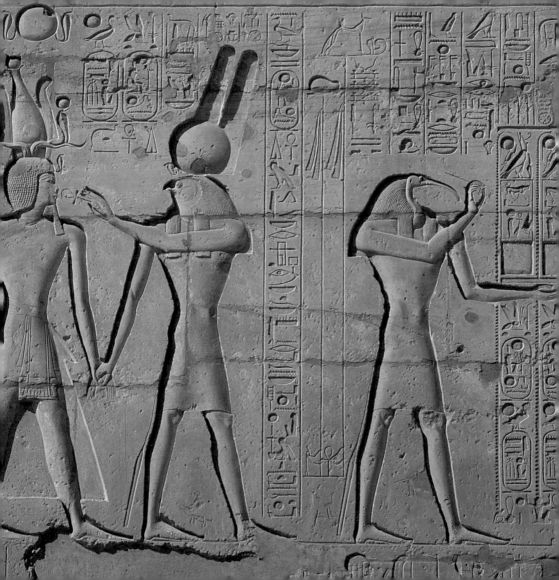

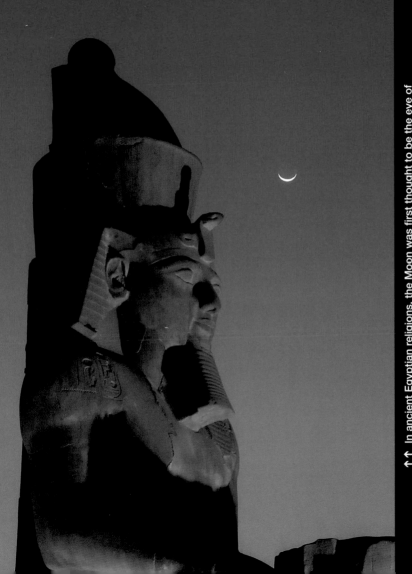

↑↑ In ancient Egyptian religions, the Moon was first thought to be the eye of Horus, the sky god; the other eye was the Sun. Eventually, the Moon became associated with Thoth, the ibis-headed son of Ra (ibis beaks having a crescent shape). Moonlight at night allows humans to mark time, and the lunar cycles became important in Egyptian culture and rituals.

↑ The crescent Moon looms over the colossus of Pharaoh Rameses II at the Temple of Luxor (ancient Thebes) in Egypt. The Moon played a critical role in the ancient religions of Egypt, as it does in modern Islamic traditions.

61

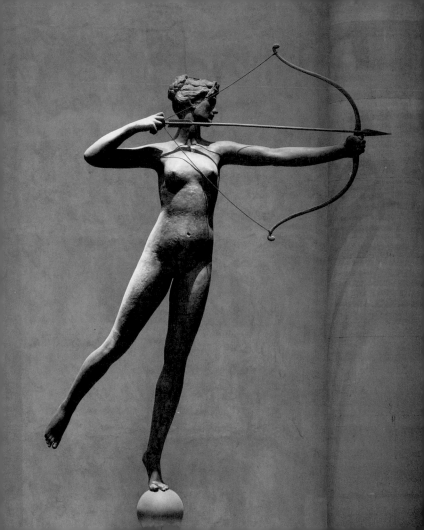

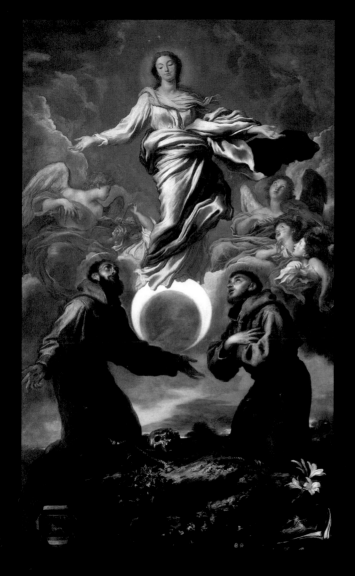

↑↑ Sculptor Augustus Saint-Gaudens created this sculpture (designed as a weathervane) of the goddess Diana in circa 1892 for the tower atop the second Madison Square Garden in New York City. A goddess of the hunt, of fertility, and of love, Diana supplanted Luna as the Moon deity in the Roman pantheon.

↑ Giovanni Benedetto Castiglione painted the Immaculate Conception of Mary, the mother of Jesus, in 1650. Mary, sometimes called the queen of the universe, is often depicted standing on the crescent Moon. This association of Mary with the Moon comes from the Book of Revelations (12:1): "...a woman arranged with the sun, and the moon under her feet, and upon her head a crown of twelve stars...."

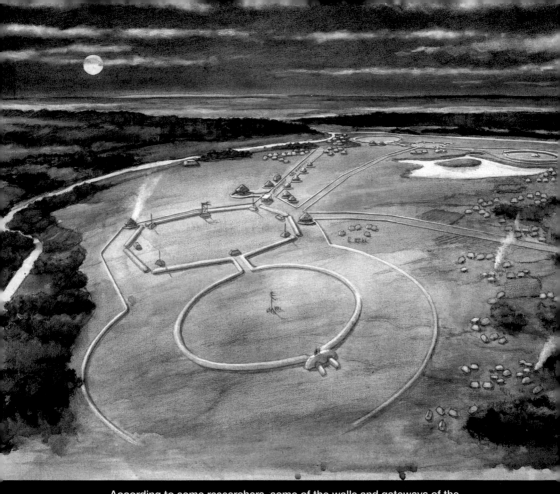

According to some researchers, some of the walls and gateways of the 2,000-year-old Newark Earthworks in Ohio (built by the ancient Hopewell "mound-building" culture) may have been aligned to serve as a long-term lunar observatory. The earth-and-rock structure purportedly chronicled the Moon's northernmost and southernmost position on the horizon over an 18.6-year cycle.

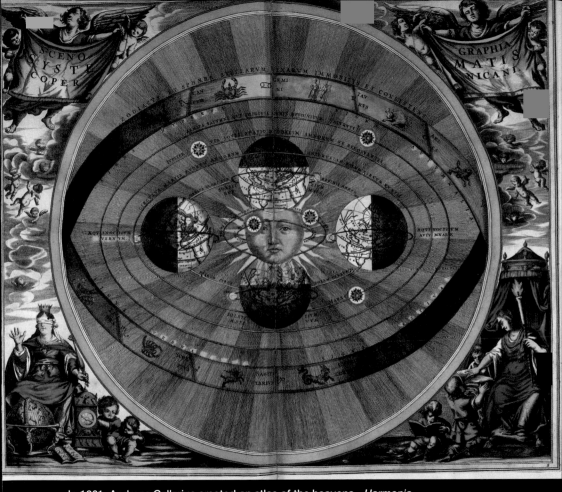

In 1661, Andreas Cellarius created an atlas of the heavens—*Harmonia Macrocosmica*—as they were understood through the worldviews of Ptolemy, Copernicus, and Tycho Brahe. The Copernican concept of the universe is

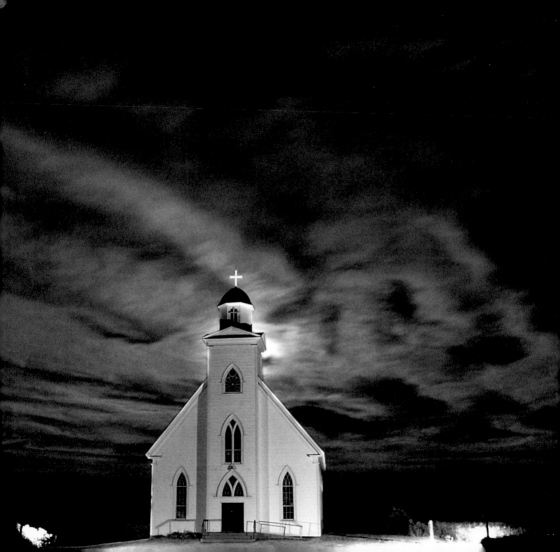

↑↑ The full Buck Moon (July) spreads its light over a church in Cape Breton Island, Nova Scotia. The date of Easter is established each year as the first Sunday after the first full Moon of spring (that is, after the vernal equinox). That custom derives from the fact that the Last Supper was a Passover Seder, and that Passover occurs on the fourteenth day of the first lunar cycle of spring.

↑ On the Apollo 14 mission, command module pilot Stuart Roosa carried hundreds of tree seeds to the Moon and back to investigate whether they would grow after being exposed to zero gravity and space radiation. Those seeds were later germinated by the U.S. Forest Service, and "Moon trees" were planted around the world (including this one in Philadelphia).

BRVEGEL
1558

VAT ICK VERVOLGHE EN GERAECKE DAER NIET AEN,
ICK PISSE ALTYT TEGEN DE MAEN.

↑↑ Flemish artist Pieter Bruegel the Elder composed a series of proverb paintings on wooden plates, offering colloquial sayings of his Renaissance time. This one roughly translates to, "Whatever I do, I do not repent, I keep pissing against the moon."

↑ Historically, the Moon has been associated with womanhood, the Sun with manhood. For that reason—and because many people could not read—the Moon was purportedly used as a symbol to distinguish the women's privy from the men's (which was marked with a star or sun).

↑↑ William Procter and James Gamble adopted this moon-and-stars trademark for their company in 1851, in an era when ancient symbols and motifs were in vogue. The logo helped wharf hands (many of whom couldn't read) distinguish boxes of Star Candles, one of P&G's early products.

↑ William Blake created this image, *The Wand'ring Moon*, as an illustration for John Milton's "Il Penseroso": "And, missing thee, I walk unseen/On the dry smooth-shaven green,/To behold the wandering Moon,/Riding near her highest noon,..."

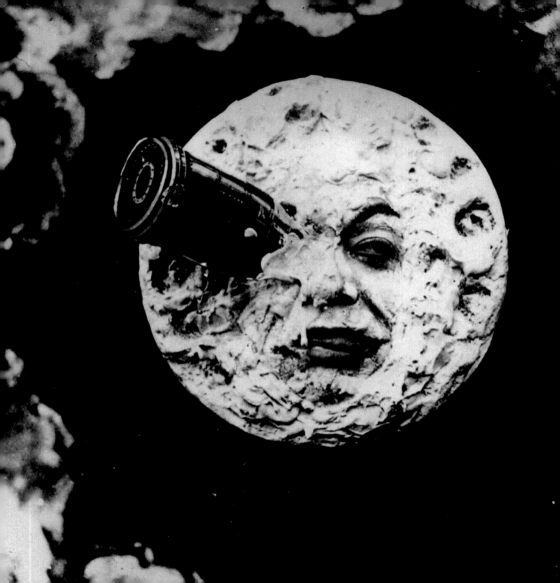

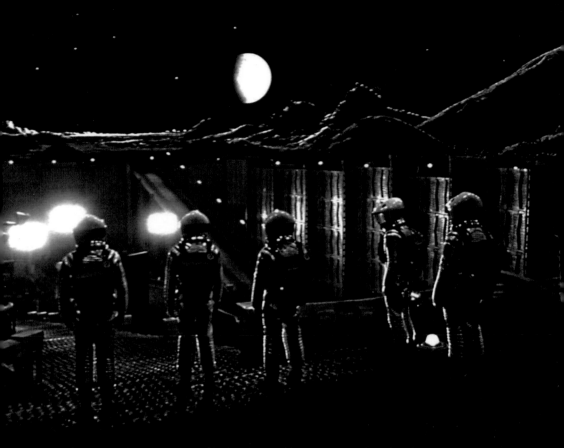

Astronauts from lunar base Clavius descend into an excavation pit to inspect the Tycho Magnetic Anomaly 1, a mysterious monolith buried by an alien culture in the Stanley Kubrick film *2001: A Space Odyssey*.

← In the 1902 silent film *La Voyage dans La Lune* (A Trip to the Moon), French filmmaker Georges Méliès attempted to blend two popular novels of the time: *From the Earth to the Moon* by Jules Verne and *The First Men in the Moon* by H. G. Wells. This scene is the earliest known example of stop-motion animation.

The graham cracker, chocolate, and marshmallow treat known as the MoonPie allegedly got its name when salesman Earl Mitchell Sr. from the Chattanooga Bakery spoke to coal miners about what they wanted in a snack. When asked how big it should be, a miner held out his hands, framed the full moon, and said, "That big."

The Moon cake is traditionally eaten during the Autumn Festival of several Asian cultures. The cakes are typically inscribed with symbols of longevity or harmony and are tied to the legends of Chang Er, the mythical Moon goddess of

GOODNIGHT MOON

60 YEARS
GOODNIGHT MOON

by Margaret Wise Brown
Pictures by Clement Hurd

In one of the twentieth century's most memorable English-language storybooks, *Goodnight Moon* by Margaret Wise Brown, the rising Moon in the window marks the countdown to bedtime for a young rabbit who says good night to all he sees in his "great green room."

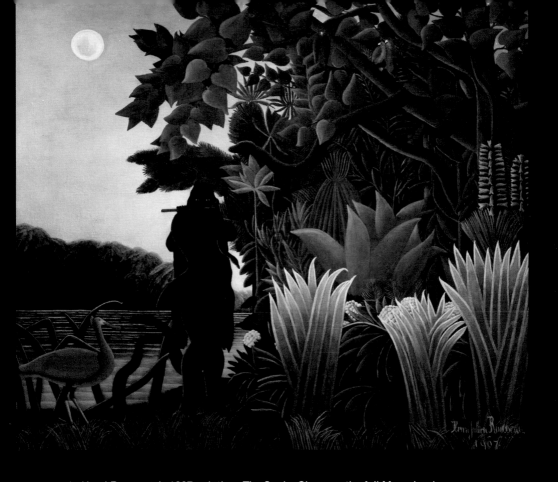

In Henri Rousseau's 1907 painting, *The Snake Charmer*, the full Moon lends an eerie, dreamlike atmosphere to the more tangible tangle of wildlife that arches over and threatens to overcome the snake charmer. Rousseau painted full moons in a number of his best-known works, adding an aura of mystery.

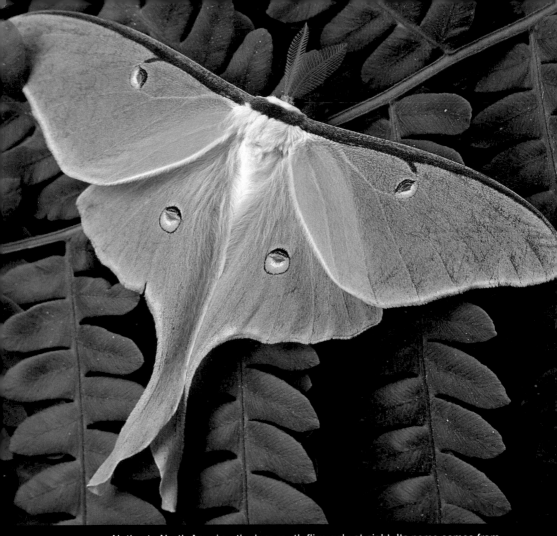

Native to North America, the luna moth flies only at night. Its name comes from the Moon-like markings on its wings.

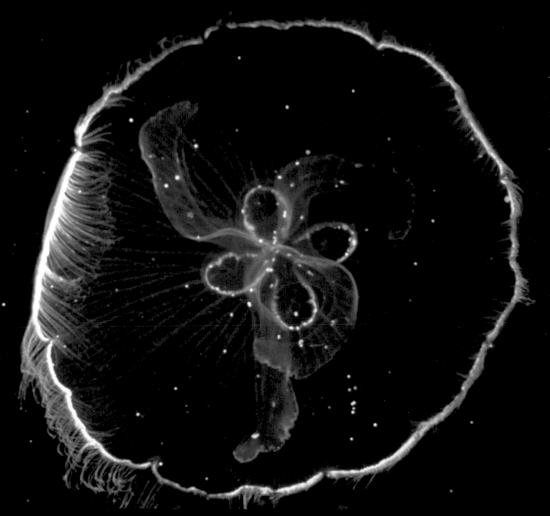

The moon jelly gets its name from its translucent, Moon-like bell. It is one of the most abundant and widely dispersed jellies in the ocean.

СФОТОГРАФИРОВАННАЯ

7.X.1959

СОВЕТСКОЙ МЕЖПЛАНЕТНОЙ СТАНЦИЕЙ

ОБРАТНАЯ СТОРОНА ЛУНЫ,

С

МОРЕ МОСКВЫ

ЗАЛИВ АСТРОНАВТОВ

ХРЕБЕТ ЛОМОНОСОВ

ЖОЛИО-КЮРИ

СОВЕТСКИЙ

ЦИОЛКОВСКИЙ

МОРЕ МЕЧТЫ

Ю

ПОЧТА СССР

60 КОП.

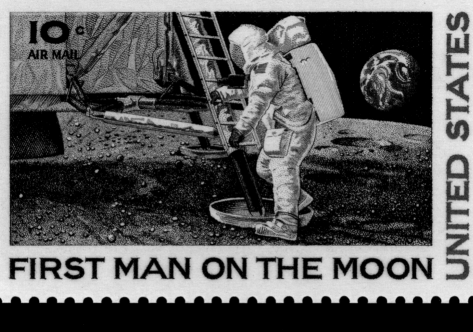

10¢ AIR MAIL

UNITED STATES

FIRST MAN ON THE MOON

Americans celebrated their triumph in the Space Race with a stamp issued on September 9, 1969. Neil Armstrong is depicted stepping from the *Eagle* onto the Moon's surface.

← The USSR commemorated the first successful photographs of the far side of the Moon with this 60-kopek stamp. The inscription on the outside of the stamp reads: "Averted side of the Moon, photographed by Soviet interplanetary station." The date 7.X.1959 refers to October 7, 1959, when *Luna 3* glimpsed the far side.

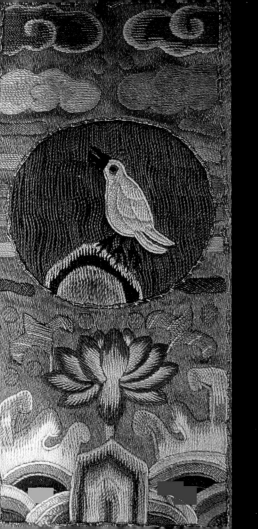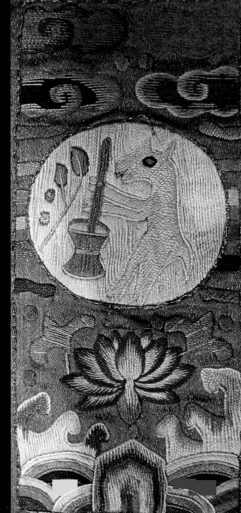

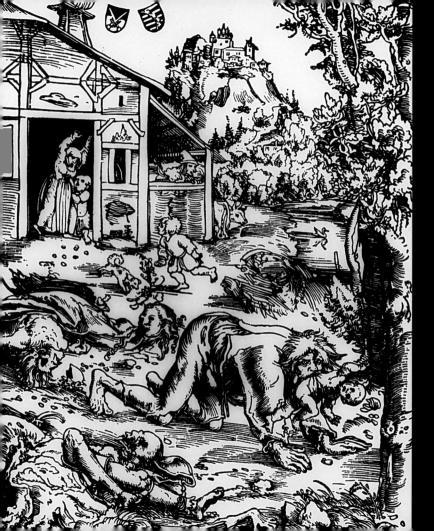

↑ In Chinese folklore, a white hare (right panel) was believed to live in the Moon, as represented in this centuries-old robe. Here, the hare is depicted in the Moon pounding the Elixir of Life in a mortar.

↑ Though the transformation of a man into a werewolf—seen here in a sixteenth-century woodcut—is usually associated with the full Moon, that wrinkle did not become part of the fabric of the werewolf story until modern fiction writers added it

By the Light of the Silvery Moon

...till the moon,

Rising in clouded majesty, at length

Apparent queen unveil'd her peerless light,

And o'er the dark her silver mantle threw.

John Milton, *Paradise Lost*

Though the Moon is primarily lit by the Sun, enough sunlight reflects off Earth's clouds and ice to faintly illuminate the "dark side." Earthshine has become an important feature of climate studies, as the amount of light reflected off our planet—or not—can tell us something about how much solar radiation is reaching Earth's surface.

WE THINK OF THE MOON AS GIVING LIGHT, BUT REALLY IT IS just reflecting it. The Moon has no means by which to generate its own visible light. Instead, it has albedo—the ability to reflect sunlight back across space. Sunlight bounces from the Moon to Earth in a little more than one second.

The Moon reflects only 7 percent of the light falling on it; by comparison, Earth reflects 39 percent. Earth's reflected light is often bright enough to allow us to see the Moon by day, provided it resides in a different quarter of the sky from the Sun. This whitish-blue moonlight of nighttime measures 0.2 lux, a unit of intensity of light; by comparison, a candle held at 30 centimeters, or one foot, throws about 10 lux.

Moonlight includes the full spectrum of light waves emitted by the Sun— ultraviolet rays, X rays, infrared light, and radio waves. While the full Moon is 400,000 times fainter than direct sunlight, it is actually much brighter in gamma rays. The Sun barely emits gamma radiation, but cosmic rays—from explosions far beyond our solar system—bounce off the lunar surface.

The first and last quarter moons (we see them as half of the disk) have one-tenth of the brightness of the full Moon, a quirk that cannot be explained by a simple change in size. The best explanation is known as the opposition effect. With the Sun, Earth, and Moon in a direct line (in that order), sunlight is shining straight down on the lunar surface, reflecting off more sunlit surfaces (like light reflected straight back from a mirror). When the Sun is at a more oblique angle from the Earth-Moon line, the mountainous features and craters throw long, deep shadows that prevent much of the lunar surface from reflecting light toward Earth.

When the light of the Moon does reach Earth, our planet's atmosphere and our human biology can play all sorts of tricks with it. Jack Brooks wrote and

Dean Martin famously sang, "When the moon hits your eye like a big pizza pie, that's amore," and that's certainly the feeling we get when we see a large silvery orb lingering near the horizon.

The Moon seems spectacularly large when it is low in the sky, and yet it is all just a trick of the mind's eye known as the Ponzo illusion. When the Moon is high, with no close point of reference, our mind interprets it as it is: far away. But when the Moon rises over the horizon—which is no more than a few kilometers away—our brains still want to interpret it as being far away. But the visual references in the foreground (trees, mountains) make it seem much closer to the eye. The irony of the illusion is that the Moon is actually 1 to 2 percent smaller when it is near the horizon because of the refraction of light by the atmosphere and because the Moon is one Earth radius farther away than when it is overhead.

Our view can be distorted in other ways. The water and gas in our atmosphere can act as a lens, bending, refracting, and scattering moonlight. For instance, when viewed on the horizon, the Moon can become flattened or egg-shaped, as density gradients in the atmosphere bend rays of light toward higher pressure and cooler air, and the lower limb is raised more than the top limb. This bending of light can also make the Moon appear to hover within Earth's atmosphere when viewed from the space station or other spacecraft.

Moonlight passing through water droplets and ice crystals in the air can exhibit prism effects. Airborne water can make nighttime lunar rainbows and fogbows in the same way that each can be created by sunlight. And as moonlight passes through the different sides and angles of ice crystals in the clouds, it can bend to make 22-degree haloes, coronae, and paraselenae (also known as "moon dogs").

According to Tony Phillips of NASA, all of this moonlight is still not enough to allow us to read a book or properly distinguish color at night. The sensitive "rods" in the retinas of our eyes can detect as little as a photon of light, but they do not detect color. The "cones" of our eyes allow us to see colors and to detect fine details (like the words of a book), but they only work in substantial light. There are a few exceptional pairs of eyeballs in the world, but most of us cannot read by the light of the Moon. (You should probably read this book by day or by lamp!)

So what is the "seeing" like on the other end of the Earth-Moon equation?

If you took a trip to the Moon and stayed for a month, you would notice that the shape of the Earth goes through phases—new, crescent, quarter, gibbous, full, and back again—though the progression is opposite; when we see a full moon from Earth, the moon has a "new Earth." In just twenty-four hours, the Earth would show all of its faces (not just one side); in one month, it would trace an oval across the sky due to the Moon's wobbly rotation, or libration.

The "big blue marble" in the lunar sky would be four times larger than the Moon's disk appears to Earthlings, and four times wider than the Sun. The earthly disk would be as much as fifty times brighter than a full Moon, throwing enough reflected sunlight—also known as Earthshine or "ashen glow"—to partially light the Moon's dark side.

On the moon, the sky is always black, since there is no atmosphere to scatter or refract the light of the Sun. That unfiltered light is brighter and whiter than what we see on Earth; in fact, it is so bright that it is nearly impossible to see any other celestial spheres and stars except the Earth. And the absence of an atmosphere means that all of the Sun's electromagnetic rays and waves penetrate to the lunar surface. This is why astronauts need to be shielded from solar radiation.

Without air, there is no twilight on the Moon; day changes to night almost instantly along the terminator. And as the Apollo astronauts learned, shadows are much darker on the Moon. On Earth, the atmosphere scatters sunlight, so some of it lands inside your shadow and brightens it. But on the lunar surface, unless you are working in direct sunlight, it's pitch-black out there.

Neil Armstrong and Buzz Aldrin noticed the effect within moments of exiting the *Eagle* lunar module (LM) in July 1969. As they tried to gather cameras and geology tools from a locker on the shadowed side of the LM, Armstrong noted: "It's quite dark here in the shadow and a little hard for me to see that I have good footing." The glassy crystals in the rocks and soil do reflect a bit of light and Earthshine helped a bit, but it took a long time for the astronauts' eyes to adjust when they moved from sunlight to shadow.

There is a haunting optical effect in the light on the Moon. Shadows are much deeper on the Moon because the lunar soil has an "open" structure that "hides" and buries the shadows. For reasons scientists don't entirely understand, moon dust piles up into microscopic but distinct towers. Since all shadows are naturally hidden by the object casting them, the towers of dust can give the lunar surface a shadowless appearance when the Sun is perched at certain angles. When the Apollo astronauts took photographs looking away from the Sun, they sometimes saw bright angelic halos around their heads.

"There is something haunting in the light of the moon," wrote Joseph Conrad in *Lord Jim*. "It has all the dispassionateness of a disembodied soul, and something of its inconceivable mystery."

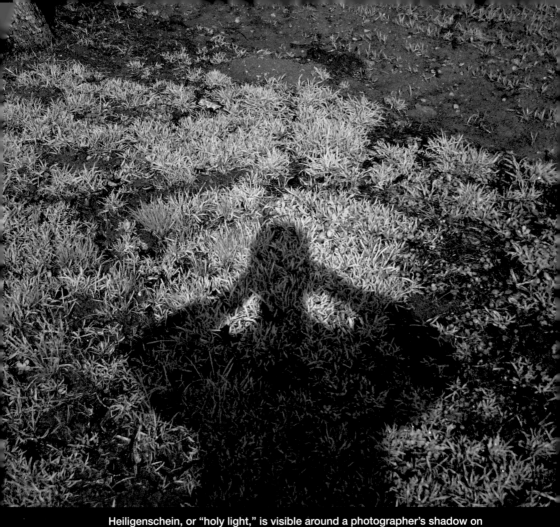

Heiligenschein, or "holy light," is visible around a photographer's shadow on the dew-covered grass. In the early evening, the moonlight passes through the drops of dew and is reflected back through the dewdrops toward the Moon.

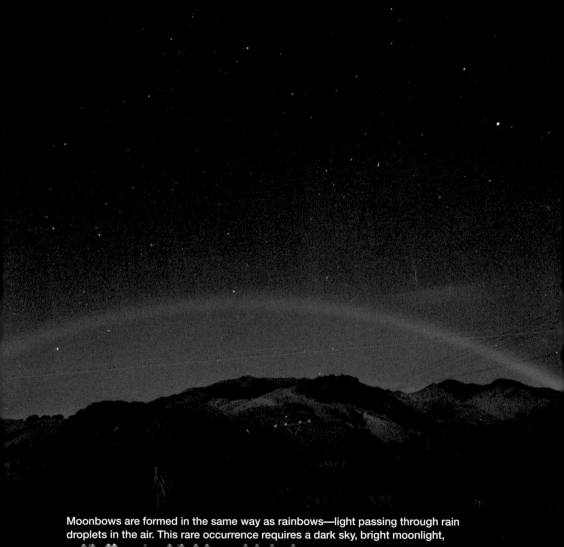

Moonbows are formed in the same way as rainbows—light passing through rain droplets in the air. This rare occurrence requires a dark sky, bright moonlight,

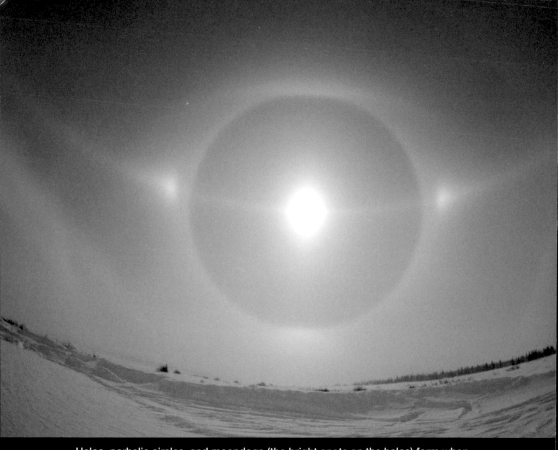

Halos, parhelic circles, and moondogs (the bright spots on the halos) form when moonlight bounces off the different faces of ice crystals in the atmosphere at different angles.

→ A halo encircles the Moon over the Old Brick Church near Albany, Missouri. Halos form about 22 astronomical degrees out from the lunar disk as millions of ice crystals in the haze of the upper atmosphere reflect and refract the light of the Moon.

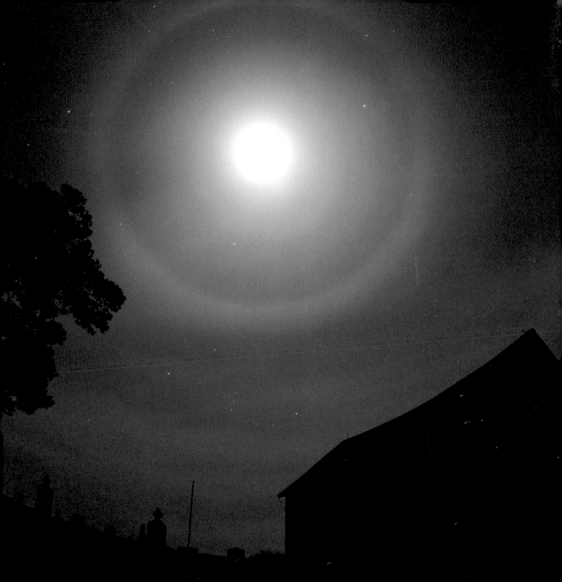

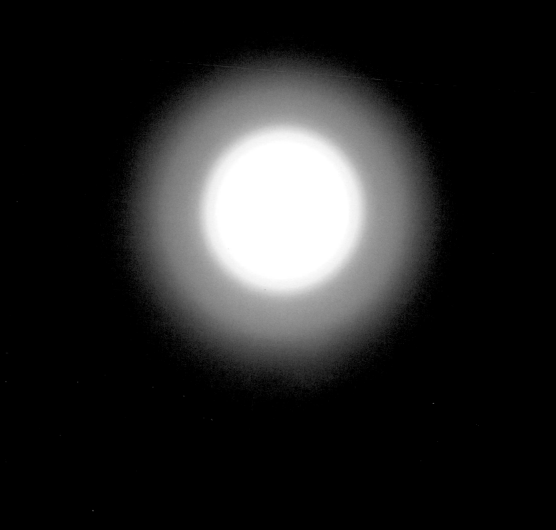

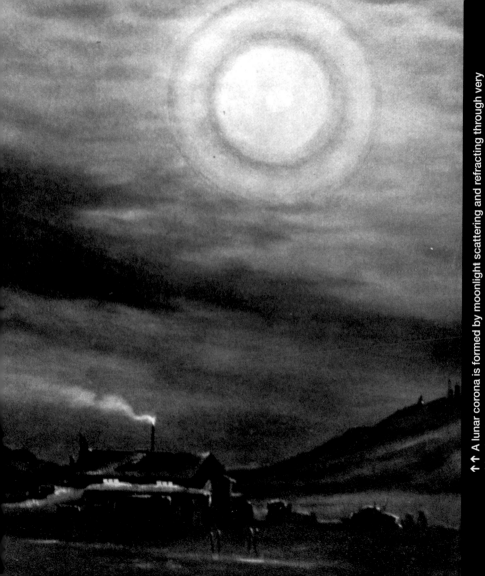

↑↑ A lunar corona is formed by moonlight scattering and refracting through very thin clouds.

↑ A sketch from the 1913 book *Scott's Last Expedition* demonstrates a lunar corona visible during Robert Scott's expedition to the South Pole.

The waning gibbous Moon hangs over the Parliament Building in Victoria, British Columbia. Though we associate the Moon with nighttime, it spends nearly half of its time in our daytime sky.

→ The Moon appears to be floating within Earth's atmosphere in this view from the International Space Station. In fact, the Moon is thousands of miles away, but the low angle of the Sun at that precise moment meant that the atmosphere was not reflecting or scattering light as much in the plane of view toward the Moon

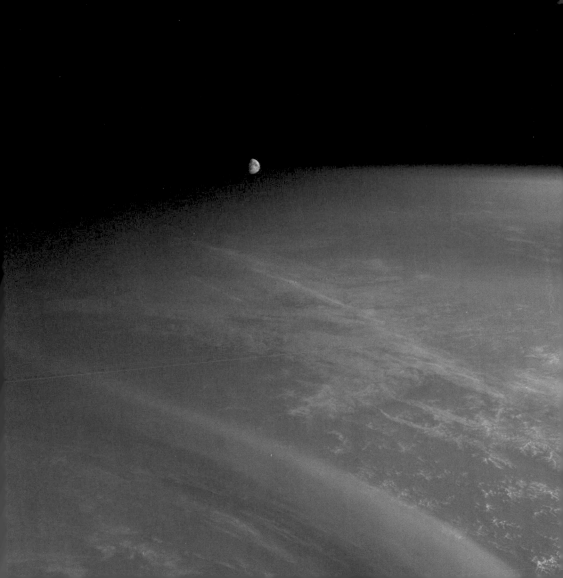

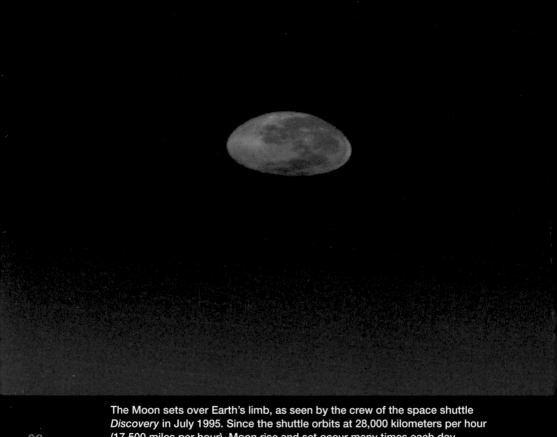

The Moon sets over Earth's limb, as seen by the crew of the space shuttle *Discovery* in July 1995. Since the shuttle orbits at 28,000 kilometers per hour (17,500 miles per hour), Moon rise and set occur many times each day.

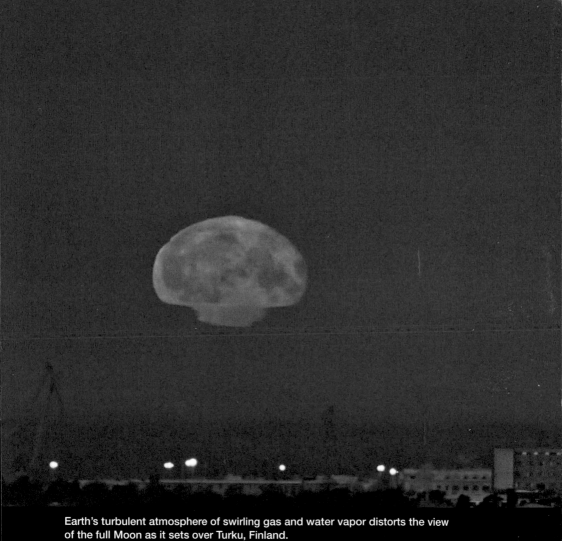

Earth's turbulent atmosphere of swirling gas and water vapor distorts the view of the full Moon as it sets over Turku, Finland.

The Moon appears much larger when it is near the horizon due to the Ponzo illusion. Your brain wants to interpret the Moon as being far away—as when directly overhead—but objects on the horizon make it seem closer and larger.

← The full Wolf Moon (January) rises over an industrial park in Halifax, Nova Scotia. Three exposure were made on one piece of film, two minutes apart.

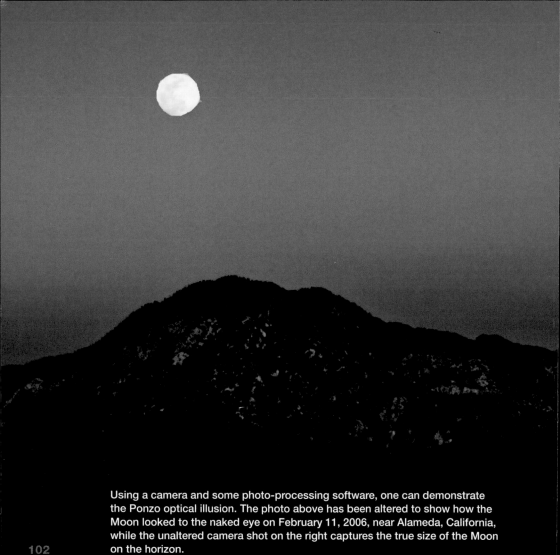

Using a camera and some photo-processing software, one can demonstrate the Ponzo optical illusion. The photo above has been altered to show how the Moon looked to the naked eye on February 11, 2006, near Alameda, California, while the unaltered camera shot on the right captures the true size of the Moon on the horizon.

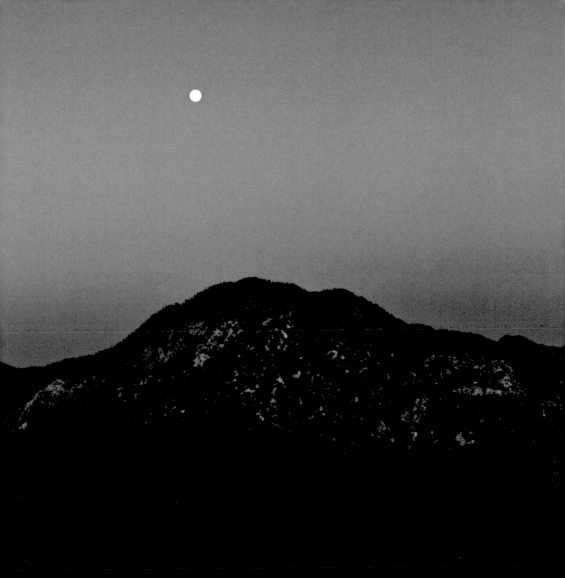

Apogee

Perigee

```
        2006-02-13              2005-07-22
        405,978 km              357,178 km
        29.87 arc-mins          33.75 arc-mins
        Altitude @ 69.17°       Altitude @ 27.60°
```

Because the Moon's orbit around the Earth is an ellipse, the Moon can appear bigger and brighter at different times throughout the year. The Moon's closest approach to Earth, or perigee, brings it within 356,000 kilometers (221,000 miles); at the farthest end of its orbit, or apogee, the Moon is roughly 406,000 kilometers (252,000 miles) away.

← During a total lunar eclipse in September 1996, the Midcourse Space Experiment satellite captured the Moon in infrared light. The bright spots reveal "warm" locations on the lunar surface, while dark areas reveal "cool" soil and rock.

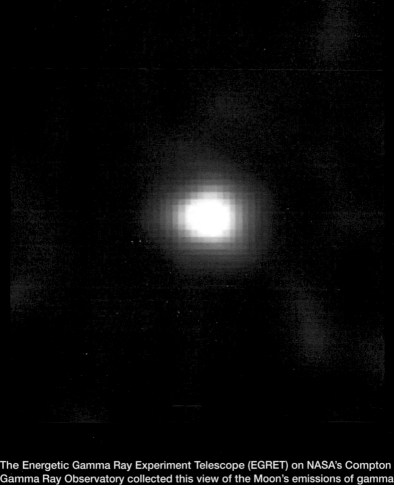

The Energetic Gamma Ray Experiment Telescope (EGRET) on NASA's Compton Gamma Ray Observatory collected this view of the Moon's emissions of gamma rays. Cosmic rays from beyond our solar system constantly bombard the lunar surface and generate gamma photons.

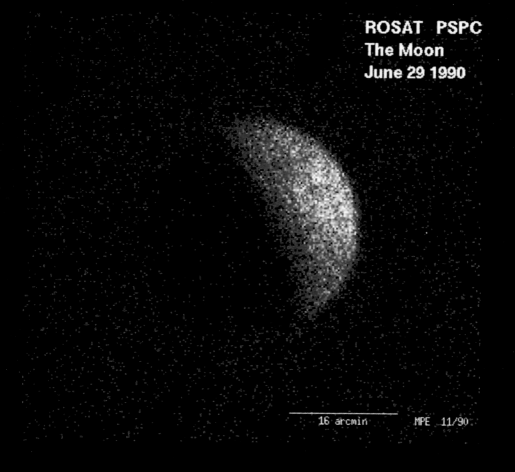

ROSAT PSPC
The Moon
June 29 1990

16 arcmin MPE 11/90

The ROSAT satellite's Position Sensitive Proportional Counters collected this
view of the Moon's X-ray emissions in 1990. Brighter areas reveal greater
emissions, which are caused by scattering of the X rays from the Sun.

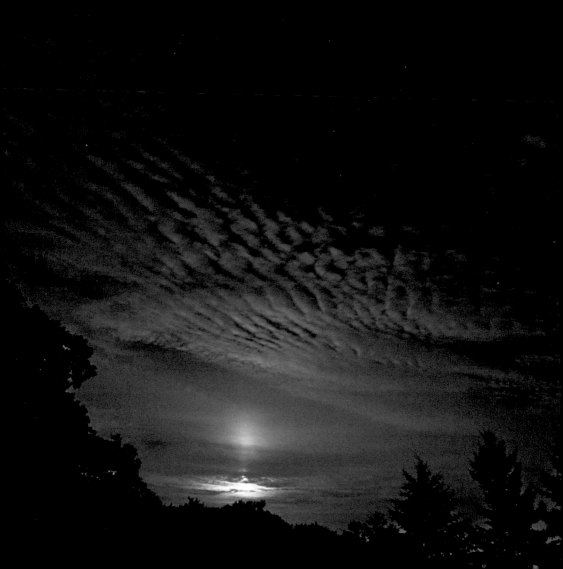

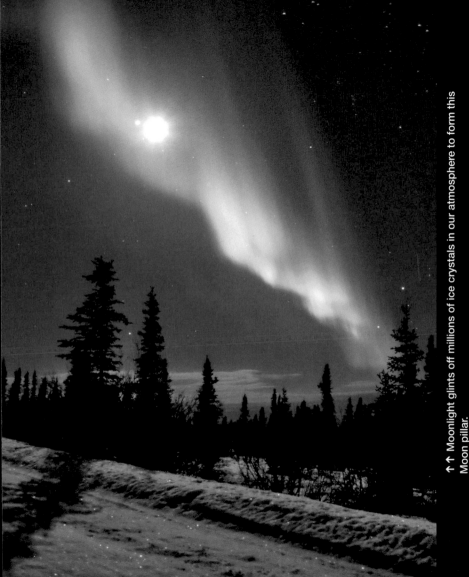

↑↑ Moonlight glints off millions of ice crystals in our atmosphere to form this Moon pillar.

↑ The Moon and Jupiter (just left of the lunar disk) compete for attention with the aurora at the spring equinox in Wickersham Dome, Alaska. Reflected and refracted moonlight was one of the many early (and mistaken) scientific explanations for the northern lights.

Fifty-seven years after Ansel Adams shot *Autumn Moon*—or exactly three "metonic" cycles later—Texas State University physicists Donald Olson and Russell Doescher and their students returned to the exact location (Glacier Point, Yosemite National Park) to photograph the same scene. They used astronomical records and dozens of photographs to figure the exact place, day, and time that Adams had snapped his camera shutter—7:03 p.m. on September 15, 1948.

As Long as the Moon Shall Rise

The moon, by her comparative proximity,
and the constantly varying appearances
produced by her several phases, has always
occupied a considerable share of the
attention of the inhabitants of the earth.

Jules Verne, *From the Earth to the Moon*

The Moon rises over the Stonehenge Aotearoa in New Zealand. The site is not intended as a replica of the famous collection of monoliths in England; instead, it is built as a working observatory, precisely measured for the alignments of Sun, Moon, and stars over the Wairarapa region.

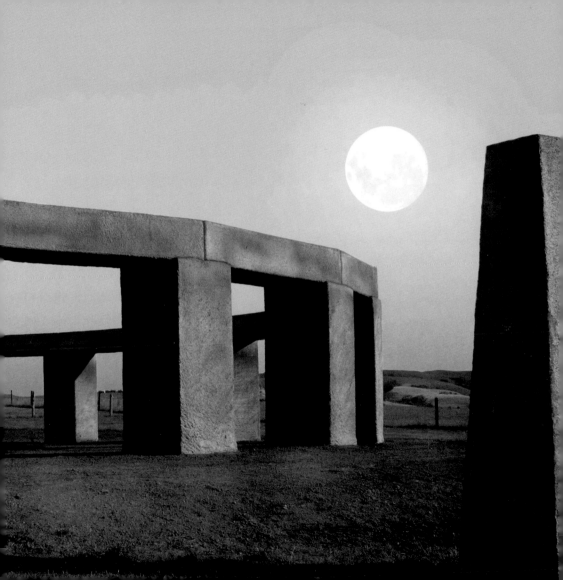

NO MATTER WHERE WE LIVE, HOW INTELLECTUAL OR SPIRITUAL
we may be, or how keen our eyesight, there is one characteristic of the Moon that is common to all of us: its changing appearance. From the thin crescent to the bulging gibbous hump to the full round disk, the Moon changes its profile daily. It makes a complete cycle monthly—new Moon, waxing crescent, first quarter (right 50 percent visible), waxing gibbous, full Moon, waning gibbous, last quarter (left 50 percent visible), waning crescent—in a pattern we call the "phases" of the Moon. Of course, it is not the Moon that changes, but the angle between the Earth, Moon, and Sun, allowing us to see more or less of the sunlit side of the Moon.

This predictable, constant pattern may be the world's oldest timekeeper, marking the passage of months and years. Depending on the time of year, the Moon can even help tell you the time of day, as the new Moon rises at dawn (roughly 6 a.m.) and sets at dusk (6 p.m.); the first quarter rises at noon and sets at midnight; the full Moon rises at dusk and sets at dawn; and the last quarter rises at midnight and sets at noon.

Though the size and shape of the visible lunar disk changes, the face beneath that light does not. We see roughly the same side of the Moon at all times because the gravitational and tidal tug of war between Earth and its satellite has locked the Moon into synchronous rotation. (We say "roughly" because the Moon wobbles slightly in its orbit—lunar libration—so we actually see a total of 59 percent of the lunar surface in a month.) Luna makes one turn on its axis in the same amount of time that it makes one orbit around Earth; essentially, one lunar day is the same as one Earth month. This phenomenon appears to be common to all of the major moons in the solar system (except Saturn's moon Hyperion).

Seeing the same face affords us time to make connections and to fix meaning and order amid the randomness and chaos of space. As Carl Sagan wrote in *The Demon-Haunted World*: "What do we actually see when we look up at the Moon with the naked eye? We make out a configuration of irregular bright and dark markings—not a close representation of any familiar object. But, almost irresistibly, our eyes connect the markings, emphasizing some, ignoring others. We seek a pattern, and we find one."

The most famous pattern is the "man in the Moon," the human face that many of us see in the alignment of dark plains of volcanic lava known as *maria*, the Latin word for "seas." Mare Imbrium (Sea of Rains) and Mare Serenitatis (Sea of Serenity) make up the eyes; Sinus Aestuum (Bay of Billows) is the nose; and Mare Nubium (Sea of Clouds) and Mare Cognitum (Known Sea) form the mouth. Other cultures have assembled the light highlands and dark *maria* into the shapes of rabbits, frogs, jaguars, and women at work.

The lunar seas themselves got their fanciful names around 1651 when Jesuit astronomers Giambattista Riccioli and Francesco Grimaldi catalogued some of the Moon's features in a treatise (one which actually argued against the cosmology of Kepler, Copernicus, and Galileo). At the time, the maria were believed to contain water and the Moon was believed to affect Earth's weather. Many of the ideas of Riccioli and Grimaldi were tossed aside, but their subdivision of the Moon into eight regions (octants) and some of their naming conventions were kept, leaving us with wonderful names such as Mare Tranquillitatis (Sea of Tranquillity), Terra Sterilitatis (Land of Sterility), Oceanus Procellarum (Ocean of Storms), and Mare Crisium (Sea of Crises).

The most spectacular of naked-eye lunar visions is the solar eclipse. It is an unlikely coincidence that the Sun and the Moon are almost exactly the same

size from the perspective of Earth; the Sun is about 400 times larger than the Moon, but it is also 400 times farther away. Solar eclipses occur when the new Moon passes directly in line between the Sun and Earth, throwing the Moon's shadow over a swatch of Earth.

But why don't we have a total eclipse at every new Moon? The Moon orbits at an angle that is tilted slightly (about 5 percent) from the ecliptic plane of Earth and the Sun, so in many months, the new Moon is not in a direct line between our planet and its star.

Total solar eclipses, where the Moon completely blocks the solar disk, occur somewhere on Earth approximately once every eighteen months. (It can take as much as 370 years for an eclipse shadow to pass twice over the same point on Earth.) The mountains and valleys on the limbs (visible edges) of the Moon help create the fantastic features known as Baily's Beads and the "diamond ring" just before and after the moment of totality. Partial and annular eclipses, in which the Moon blocks the Sun incompletely, are less revered yet more frequent, occurring at least once a year. The geometry is reversed in a lunar eclipse, as the full Moon passes through Earth's long shadow. Lunar eclipses appear red and brown because sunlight is bent, or refracted, around the curve of the Earth's atmosphere.

One of the most infamous lunar eclipses occurred on February 29, 1504. Christopher Columbus and his crew were stranded in St. Anne's Bay, Jamaica, during their fourth voyage to the New World. Desperate for supplies—which had been cut off by the local tribes who were weary of the awful treatment by the Europeans—Columbus used navigational and astronomical references to play a trick. After deducing that a lunar eclipse was going to occur, he told the native leaders that his God was going to take away the Moon until the tribes resumed

their aid for his crew. When the Moon turned red with the eclipse, Columbus found himself being begged by terrified tribes to bring back the Moon.

It was the observation of eclipses, seasons, and lunar features that led the ancients to build their "henges" (Stonehenge, Woodhenge) and mounds (Newgrange, the Newark Earthworks). At a Stone Age mound in Knowth, Ireland, researchers believe they have found one of the earliest naked-eye maps of the Moon. The 4,800-year-old carvings apparently represent the lunar seas, or maria, as seen from the mound on a night of a full Moon. Indeed, before the development of optics in the medieval and Renaissance eras, it was often the astrologers, druids, and shamans who systematically documented the motions and patterns of the Moon.

The invention of the telescope at the dawn of the seventeeth century changed everything. Galileo is often credited with being the first to use a telescope for astronomy, and in 1609 he drew one of the first telescopic drawings of the Moon. Two decades later, Pierre Gassendi and Claude Mellan made a detailed map of lunar features that was used to study a lunar eclipse and the problem of measuring longitude on Earth. Johannes Hevelius made extensive engravings of every phase of the Moon in support of his treatise *Selenographia*, the first book devoted solely to the Moon. Selenography—the study of Selene, our Moon—was born.

Over four hundred years, the equipment has improved, the techniques standardized, and photography has made the depiction of lunar features much more precise. But the basic approach to ground-based study of the Moon hasn't changed much. Choose a clear night, get away from the lights of civilization, and look toward the terminator—the edge of day and night on the Moon, where the shadows are stark and the viewing is best.

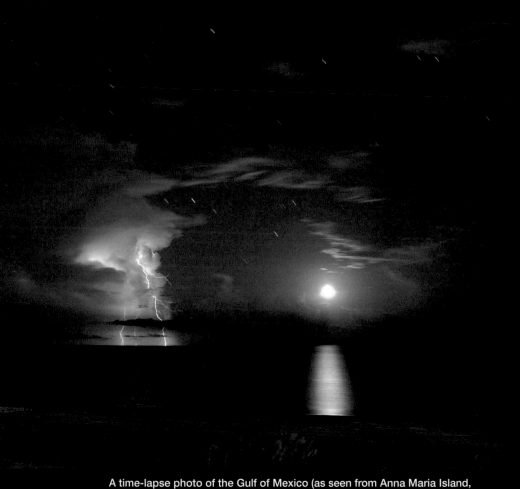

A time-lapse photo of the Gulf of Mexico (as seen from Anna Maria Island, Florida), shows the first quarter Moon framed by the constellation Scorpius and a bit of late-summer lightning.

→ The thin crescent Moon sets over Turku, Finland.

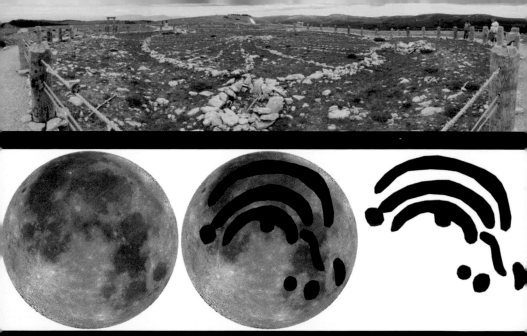

↑↑ In the Bighorn Range of Wyoming, ancient tribes built a "medicine wheel" of stones that are believed to help measure and predict the cycles of the Moon and the Sun. The wheel has 28 spokes, just as there were 28 posts—for the days of the lunar month—used in the ceremonial buildings of the Lakota.

↑ At the great Stone Age "passage mound" in Knowth, Ireland, researchers believe they have found one of the earliest naked-eye maps of the Moon. They believe the 4,800-year-old stone carvings represent the lunar seas, or *maria*.

→ Johannes Hevelius sketched this view of the Moon for his 1647 work *Selenographia*, the first treatise dedicated entirely to the Moon. Hevelius suggested a system for naming lunar features and developed many different approaches to mapping. He is credited with starting the science of selenography, the study of the Moon's geology and topography.

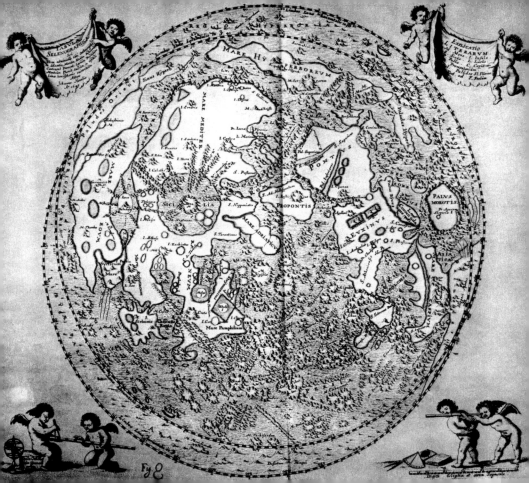

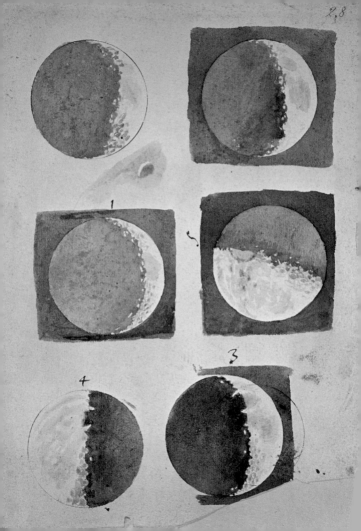

↑↑ Galileo Galilei was one of the first to observe our Moon through a telescope. He made these wash drawings of the Moon's phases around 1610, including faint hints of the craters, valleys, and mountains he spied. Those observations became part of his growing (and controversial) evidence that heavenly bodies were not perfect, unadulterated spheres.

↑ This frontispiece appeared in *The Discovery of a World in the Moone*, a book by John Wilkins, published in 1638, speculating on travel to the Moon by "a flying chariot." Because the book embraced the Copernican ideal that the Earth is but one of the planets, it was published anonymously.

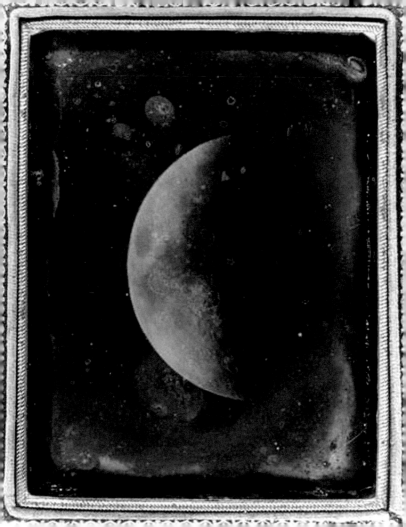

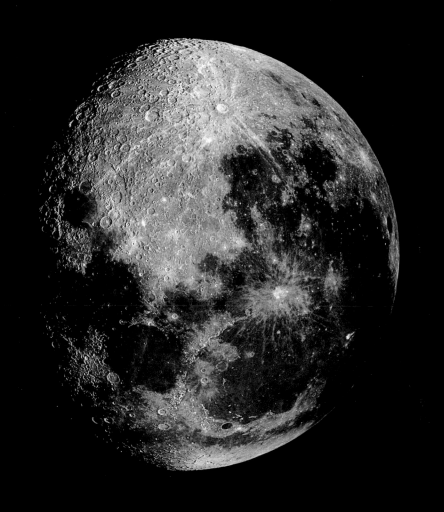

↑↑ J.A. Whipple of the Harvard College Observatory took one of the earliest photos—actually a daguerreotype—of the Moon in February 1852.

↑ The gibbous Moon—larger than a quarter, but less than full—derives its name from the old French word for "humpbacked."

125

An amateur astronomer captured this view of the exceedingly thin crescent a day before the Moon entered its "new" phase in July 2006.

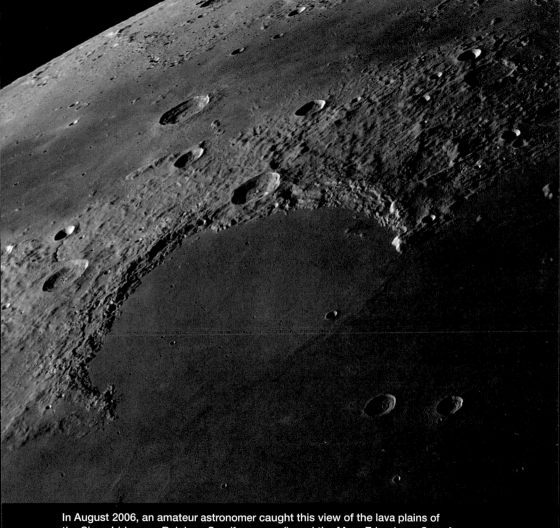

In August 2006, an amateur astronomer caught this view of the lava plains of
the Sinus Iridum, or Rainbow Sea (foreground), and the Mare Frigoris, or Sea of

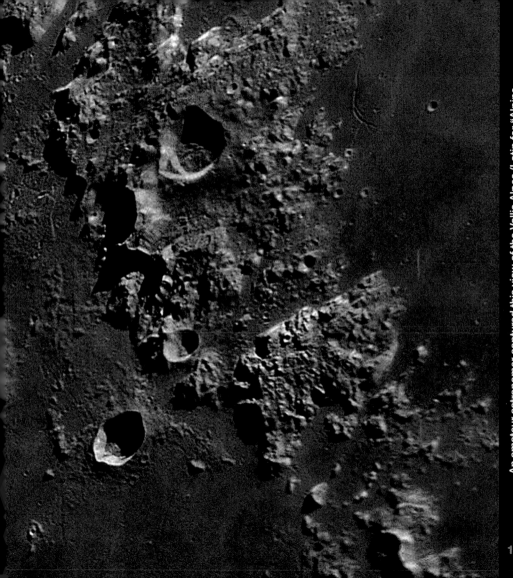

An amateur astronomer captured this view of the Vallis Alpes (Latin for "Alpine Valley"), Cassini Crater (center), and surrounding areas in August 2006.

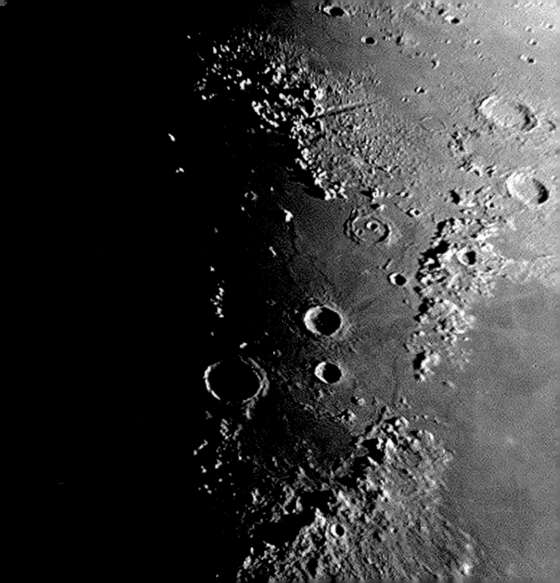

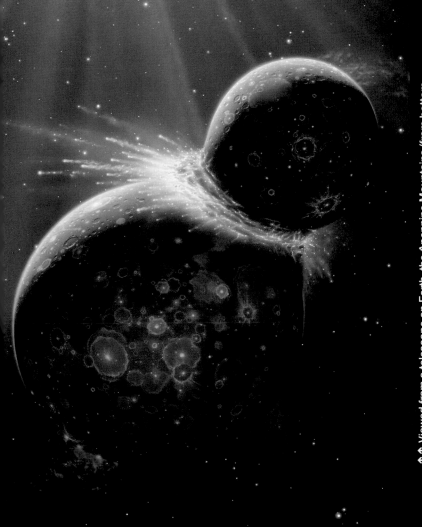

↑↑ Viewed from a telescope on Earth, the Apennine Mountains (from bottom left to center) loom over the Alpine Valley and its three large craters—Aristillus, Autolycus, and Archimedes. The Apennines stretch as high as 5,400 meters (16,400 feet) above the surface of the moon.

↑ One of the leading theories about the formation of the Moon suggests that a Mars-sized planet smashed into the primordial Earth (illustrated here), spraying large, molten pieces of crystal rock out of the planet. Those pieces of debris eventually coalesced, cooled, and condensed to form the Moon.

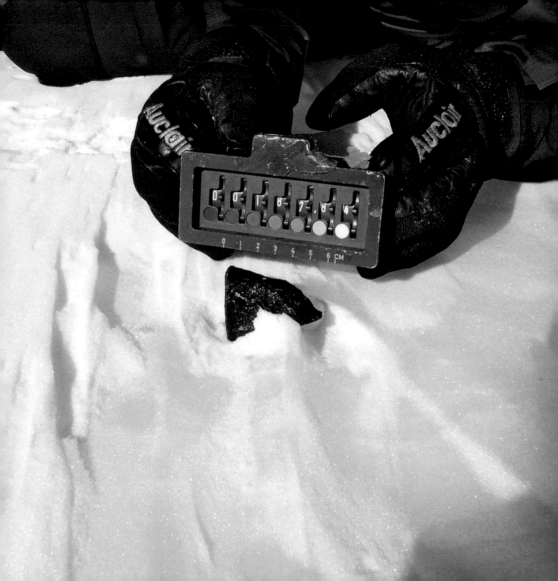

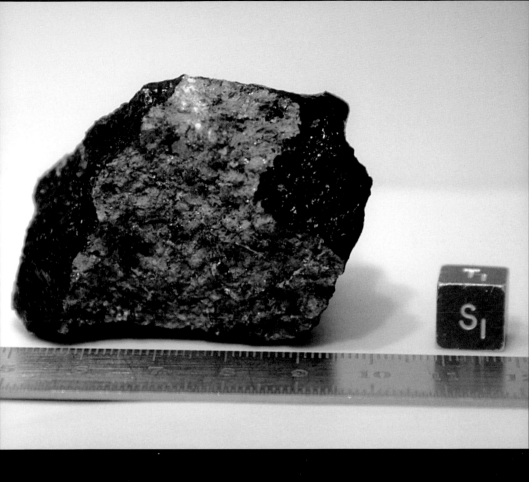

Researchers working in Antarctica collected this unusual lunar sample in
December 2005 in the Miller Range of the Transantarctic Mountains. Slightly
larger than a golf ball, the rock was blasted off the Moon by an impact millions—
perhaps billions—of years ago.

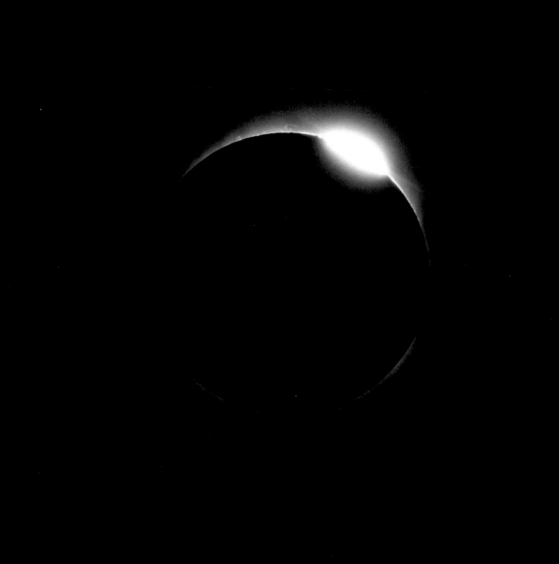

↑↑ During solar eclipses, the topography of the Moon—specifically the mountains and craters along its limb—create this diamond-ring effect, as sunlight pours through the gaps in the edge of the disk.

↑ The Moon's shadow stretches over Antarctica during a total solar eclipse on November 23, 2003. Note the fuzzy, lighter part of the shadow around the edges— the penumbra—surrounding the inner shadow, or umbra.

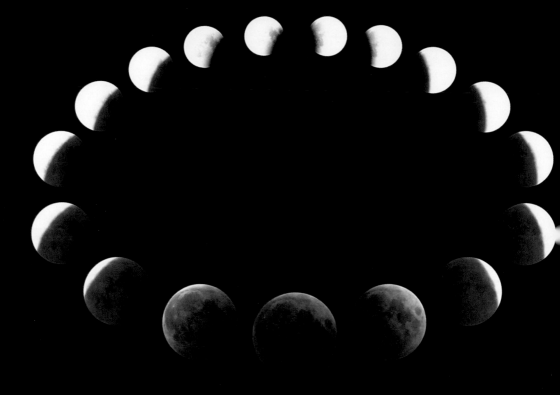

This composite shows the movement of Earth's shadow across the face of the Moon during the lunar eclipse of October 28, 2004. A lunar eclipse can occur only when the Moon is full. Since the Moon's orbit is tipped about 5 degrees from Earth's orbital plane, it passes through Earth's shadow only a few times a year (sometimes not at all).

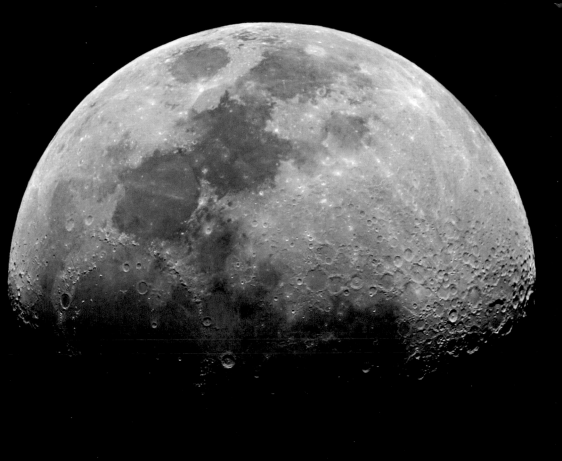

The gibbous Moon—seen here over Masterton, New Zealand—is so named because it is humpbacked; the visible portion of the Moon is greater than a quarter, but not full.

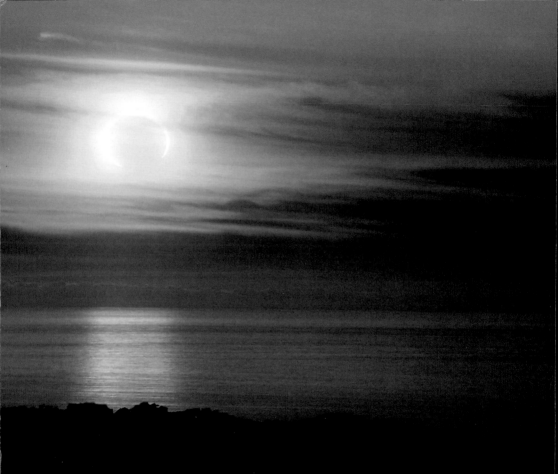

As the Sun set over the San Diego coastline on January 4, 1992, the Moon passed in front of it to form an annular (or "ring") eclipse.

→ Because the Moon's distance from Earth changes throughout the year, not all eclipses are total. This "ring of fire" annular eclipse was viewed from Spain on October 3, 2005.

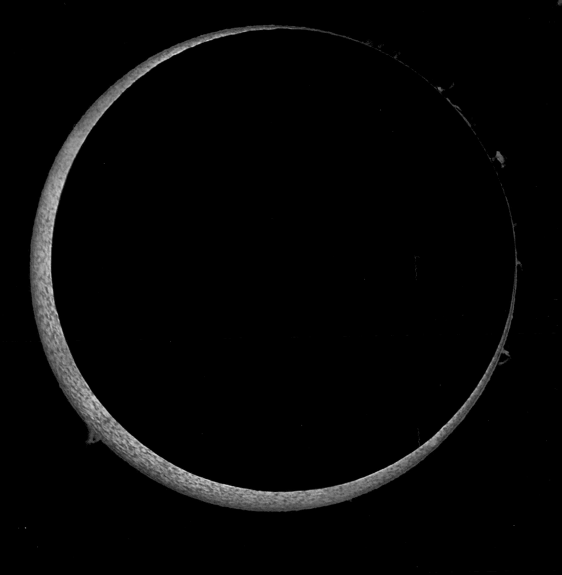

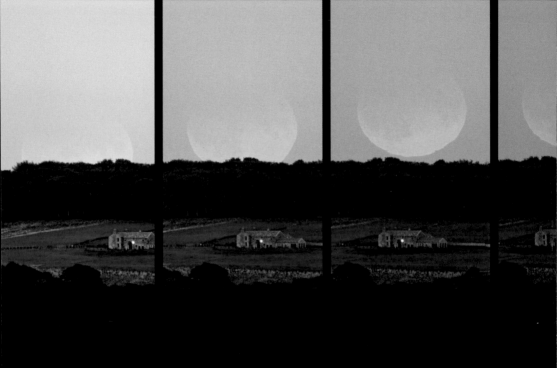

The Moon rises into Earth's shadow over Huddersfield, England, during a partial lunar eclipse in September 2006.

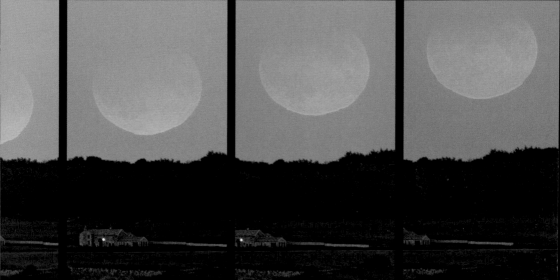

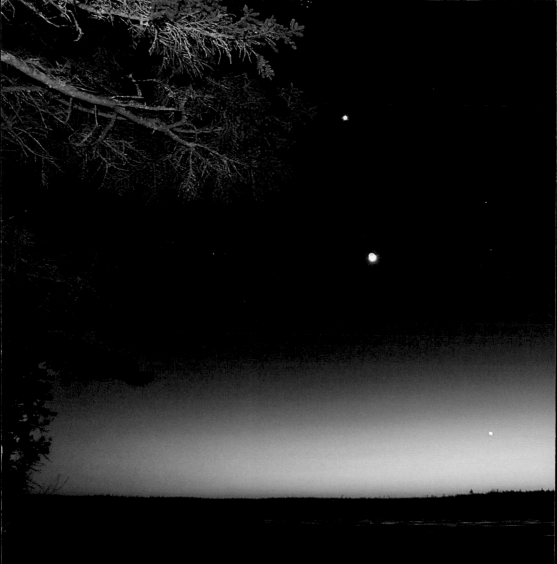

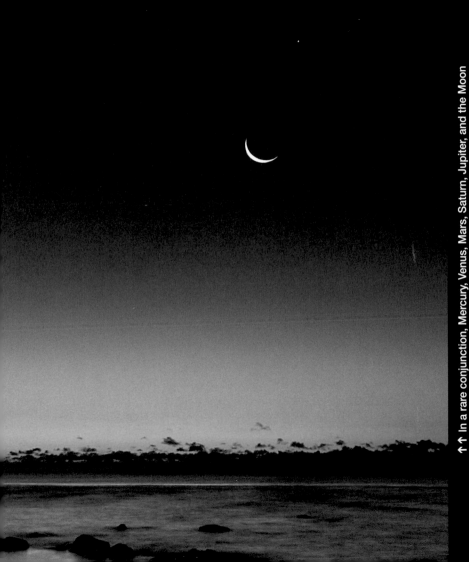

↑↑ In a rare conjunction, Mercury, Venus, Mars, Saturn, Jupiter, and the Moon simultaneously fill the same swatch of sky over Grand Lake, Nova Scotia, in March 2004.

↑ The waning crescent Moon lines up with Jupiter and Venus over the ocean near Dartmouth, Nova Scotia, in November 2004.

Magnificent Desolation

Every one is a moon, and has a dark side
which he never shows to anybody.

Mark Twain

A crescent Earth lingers over the western limb of the Moon, as viewed by *Lunar Orbiter 4* in May 1967.

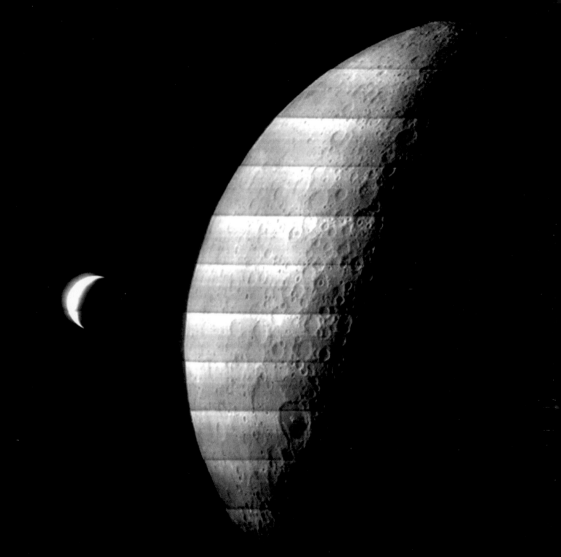

IN A HALF CENTURY OF SPACE FLIGHT, SIXTY-SIX SPACECRAFT
have been launched toward the Moon, with forty-eight successfully reaching
their target. The manned Apollo missions have justifiably garnered most of the
world's attention and admiration, but the space scientists would remind us that
it was the fifty-seven unmanned craft that have taught us as much or more
about Earth's nearest celestial neighbor.

For a nation that allegedly "lost" the Space Race, Russia sure made a lot
of firsts. From 1959 through 1976, the Russians launched twenty-four Luna
spacecraft and five Zonds ("Probes"), with twenty successful missions. On
January 2, 1959, *Luna 1* was the first spacecraft to fly past the Moon, and
in September of that year, *Luna 2* was the first vessel to land on the Moon.
Luna 3 snapped the first photographs of the far side in October 1959, and
Luna 9 made the first soft landing on the lunar surface in February 1966. The
pinnacle of the Soviet program came in September 1968 when the *Zond
5* became the first probe to orbit the Moon and return to Earth. It carried
a veritable ark of living creatures, including turtles, wine flies, meal worms,
plants, seeds, bacteria, and other living matter. Even into the 1970s, after
the Americans had set foot on the Moon, the Russians sent two rovers—
Lunokhods—and returned rock samples via their Luna spacecraft.

For the United States, the journey to the Moon started slowly and built
to a crescendo. Six of the nine Ranger lunar impact missions failed—they
were designed to fly straight toward the Moon and smack into the surface. It
wasn't until July 1964 that the Americans had their first close-up photo of the
lunar surface, compliments of *Ranger 7*. Seven Surveyor lunar landers were
launched to determine if the Moon's surface could support a landing space-
craft; *Surveyor 1* made the first "soft" lunar landing of an American craft in

June 1966, four months after the Russians. Finally, five Lunar Orbiter spacecraft surveyed and mapped the Moon in 1966–67, photographing 99 percent of the surface and preparing the way for the Apollos.

In the years since those heady days of space exploration, only five missions have been launched toward the Moon, and two of those were actually intended for other targets. NASA's Galileo mission flew past the Moon in 1990 and 1992, using its gravity to slingshot across space to Jupiter. In 1991, the Japanese Hiten spacecraft became the first probe to the Moon by a nation other than Russia or the United States. In 1994, the U.S. Department of Defense and NASA combined to send the *Clementine* probe to the Moon as part of the Strategic Defense Initiative; that mission collected the most comprehensive maps of the lunar surface to date.

AsiaSat 3/HGS-1 became the first satellite to be maneuvered into geosynchronous Earth orbit through a lunar flyby. The Hong Kong–built communications satellite was supposed to have a traditional launch, but after several failures and a change in ownership, the craft was flown past the Moon on its way back to Earth. It was the first commercial satellite to reach the Moon.

The NASA-built Lunar Prospector of 1998–99 provided extensive surveys of the poles and gathered much of the evidence for water-ice in the permanently shaded, deep craters on the top and bottom of the Moon. The first European Space Agency trip to the Moon—SMART 1—was launched in 2003 and intentionally crashed into the lunar surface in September 2006.

We have learned a lot about ourselves and about technology on the way to the Moon, but what have we learned about this natural satellite itself? We know from telescopic measurements and from spacecraft that the Moon is 3,476 kilometers wide (2,155 miles), about one-quarter of the Earth's width,

with a surface area roughly equal to the continent of Africa. The Moon is comparable in size to the terrestrial planets—Earth, Mars, Venus, and Mercury—and some would consider Earth and the Moon to be a double planet, given their comparable size. The Moon is more than two-thirds the size of Mercury, and it is larger than all of the "plutons" or "dwarf planets," which include Pluto, the asteroid Ceres, and the would-be tenth planet, Eris.

The crust of the Moon averages 65 kilometers (40 miles) thick—much deeper than that of Earth—but it is unevenly distributed. In fact, the crust on the near side is thinner than on the far side. The entire lunar surface is covered in a fine, compacted dust and rocky debris known as regolith, which can be anywhere from 3 to 20 meters (10 to 66 feet) thick. With no wind, water, or geologic activity remaking the lunar surface, this lunar soil casts near-permanent imprints when collisions explode it out of the Moon's crust.

The bright areas of the lunar surface are the highlands, the oldest terrain on the Moon. Many of these regions are labeled as mountains (and often named for ranges on Earth), but they are mostly the rims of the Moon's massive impact craters; large craters also have central peaks where the crust rebounded after a collision. Canyon-like cracks and wrinkles—rilles—in the lunar surface stand amid these highlands, possible remnants of old lava flows.

The most readily viewed lunar features are the maria, which cover about 16 percent of the lunar surface. These lowland "seas" are actually regions where ancient lava flows spilled onto the surface after the Moon was bombarded by space rocks. Curiously, only 3 percent of the lunar far side is covered with maria, compared to nearly 30 percent on the near side.

After the maria, the Moon's most famous and obvious landforms are the craters. There are at least 30,000 craters with a diameter of one kilometer or larger,

and each is the result of an impact from a space rock that smacked into the surface. The majority of the Moon's craters are between 3.1 and 3.9 billion years old, remnants of a period of heavy bombardment in the young solar system.

On Earth, most craters have long since been swept away by wind or water, or paved over by tectonic activity and volcanism in Earth's crust. But on the Moon, which has been geologically dead for billions of years, every flying asteroid, boulder, or pebble leaves a lasting scar. Lunar "rays" often spread out in all directions from a central crater, formed by the splash and spray from the explosive impact.

On the near side, most of the craters are named for famous scientists, explorers, and classical figures, such as Copernicus, Clavius, Plato, and Ptolemy. Tycho Crater, nearly 85 kilometers (52 miles) wide, stands as one of the Moon's youngest at just 100 million years old. On the far side, many features were named for more modern legends such as Yuri Gagarin, Sergei Korolev, Robert Goddard, H. G. Wells, and Jules Verne.

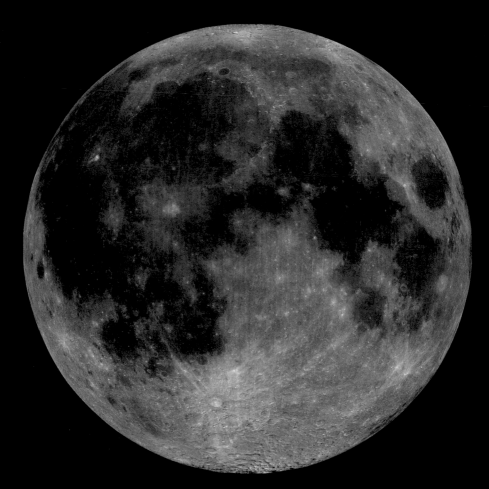

Researchers pieced together more than 50,000 photos from *Clementine* to make these orthographic projections of the near side (above) and far side (right) of the Moon. Dark maria regions are basins and valleys, while bright features are highlands.

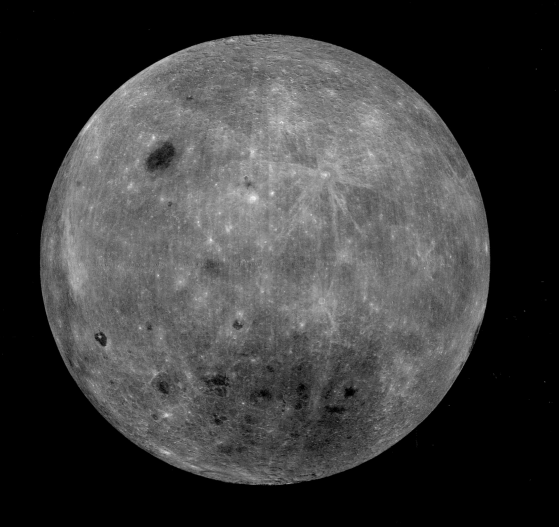

151

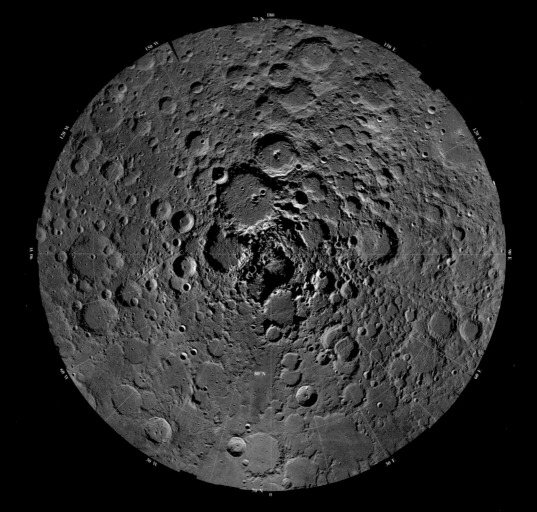

Nearly 1,500 images from *Clementine* were spliced together to provide these views of the north and south poles of the Moon. Scientists have speculated that ice may be present at the poles, which have many permanently shadowed areas.

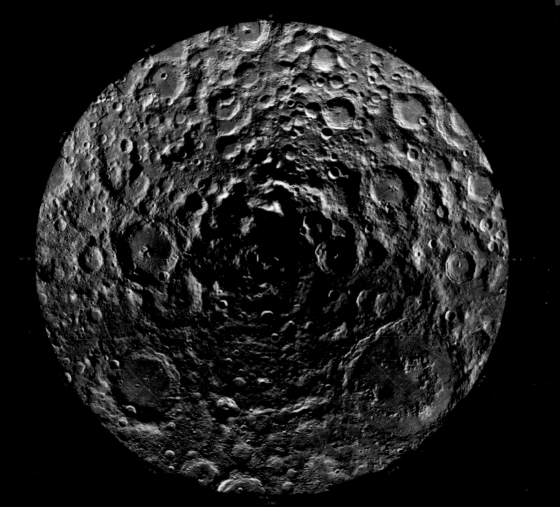

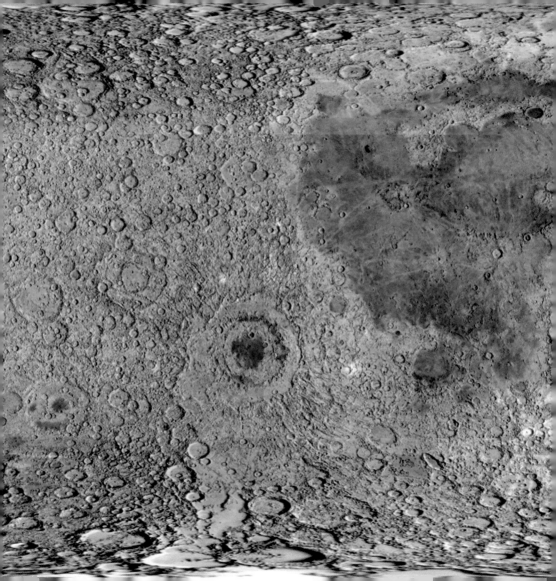

This global mosaic, captured from thousands of images by *Clementine*, shows the entire lunar surface projected as a flat map.

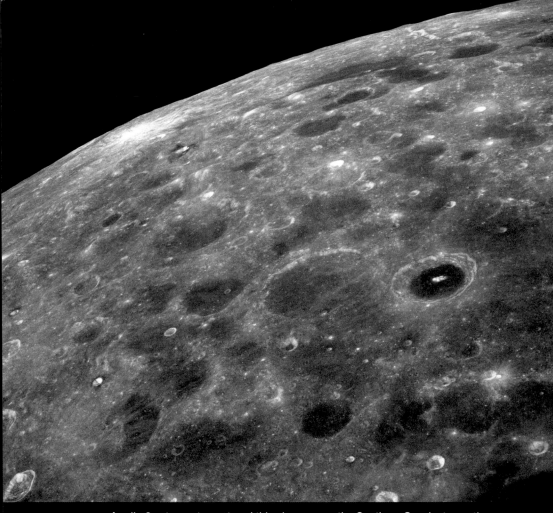

Apollo 8 astronauts captured this view across the Southern Sea, just over the eastern limb (out of earthly view) of the Moon.

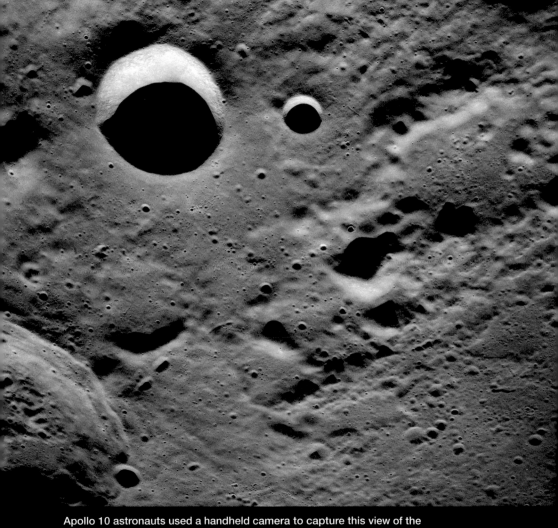

Apollo 10 astronauts used a handheld camera to capture this view of the shadowy craters near the lunar equator in May 1969. Shadows on the Moon are much darker than on Earth because there is no air to refract and reflect light.

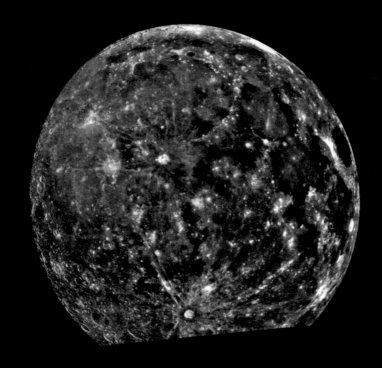

In this false-color view of the Sea of Tranquility (Mare Tranquillitatis) and the Ocean of Storms (Oceanus Procellarum), blue areas show soils rich in titanium, while oranges and purples are poor in titanium and iron. Scientists decipher the geologic history of the Moon from the composition of its surface.

→ Another false-color composite (from 15 photos) gathered by the *Galileo* spacecraft shows lunar highlands in red, while lava-filled maria are blue. Small purple areas represent pyroclastic deposits—ash and rock that spewed from ancient volcanic eruptions.

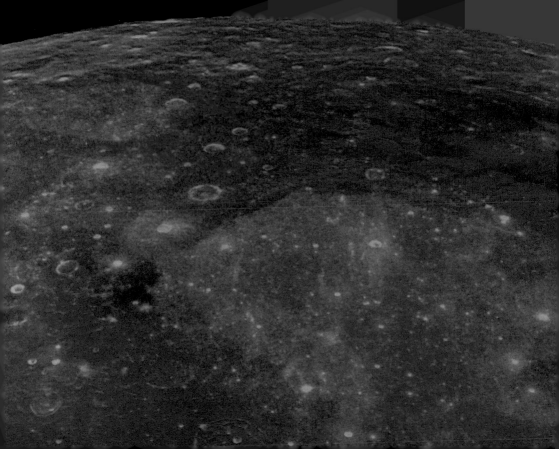

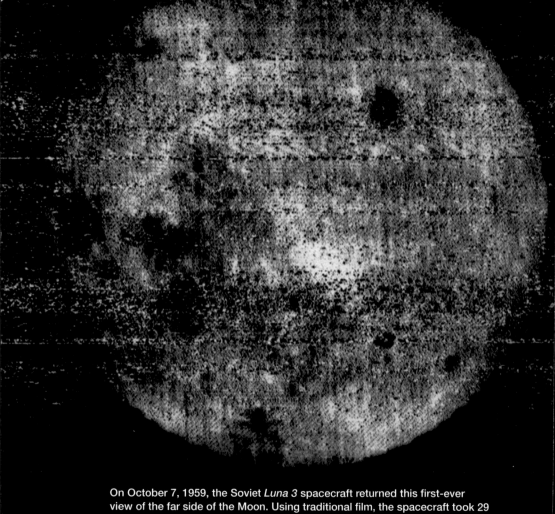

On October 7, 1959, the Soviet *Luna 3* spacecraft returned this first-ever view of the far side of the Moon. Using traditional film, the spacecraft took 29 photographs, developed and scanned them on-board, and sent back the 1960s equivalent of a fax. About 70 percent of the far side was depicted, revealing to scientists that there are far fewer maria.

In 1994, the *Clementine* spacecraft snapped this photo of the ecliptic, the horizontal plane on which all of the planets orbit the Sun. Saturn, Mars, Mercury, and the Moon (from left to right) lie at different distances from the Sun, but they were all in the same plane of the sky for this shot.

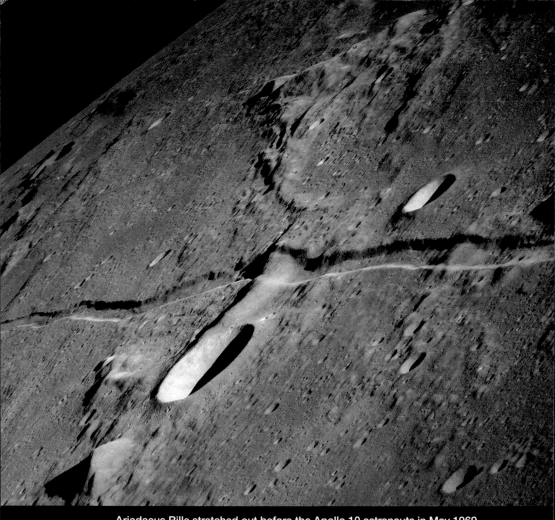

Ariadaeus Rille stretched out before the Apollo 10 astronauts in May 1969.
Rilles, channels in the lunar surface, were first discovered about 200 years ago.

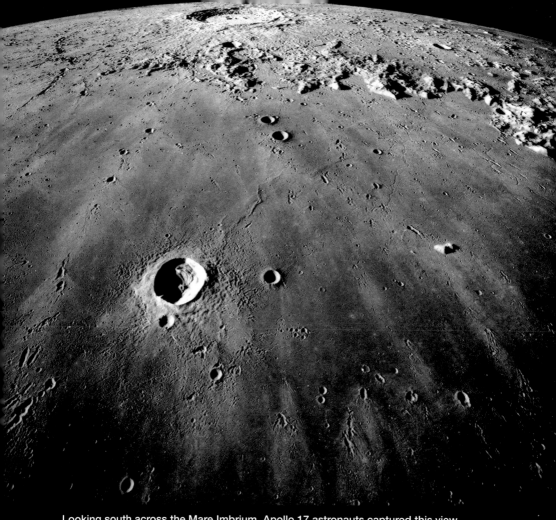

Looking south across the Mare Imbrium, Apollo 17 astronauts captured this view of the craters Pytheas (foreground), 20 kilometers (12.5 miles) in diameter, and Copernicus (background), 93 kilometers (58 miles) in diameter.

Earth Moon

The *Mars Odyssey* spacecraft captured this view of Earth and the Moon in the same frame, showing the relative size of the two bodies—Earth's diameter is 12,756 kilometers (7,926 miles), the Moon's is 3,476 kilometers (2,159 miles)—and their true distance from each other.

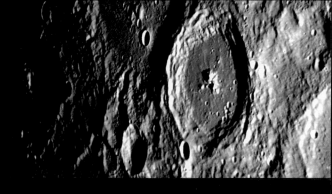

The full Earth rises over the Moon on March 13, 1994, as viewed by the *Clementine* lunar observing spacecraft.

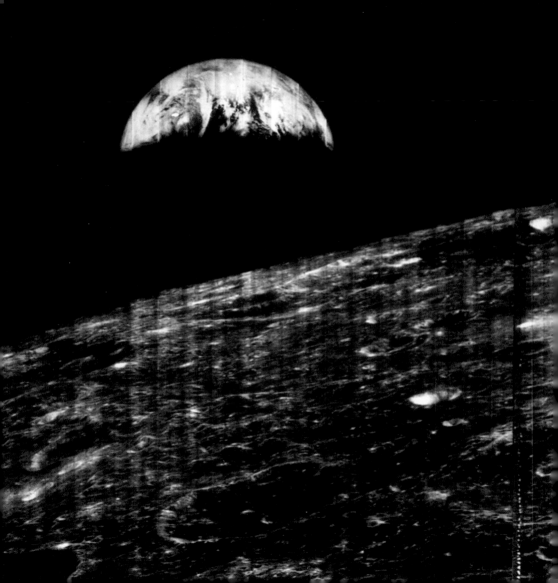

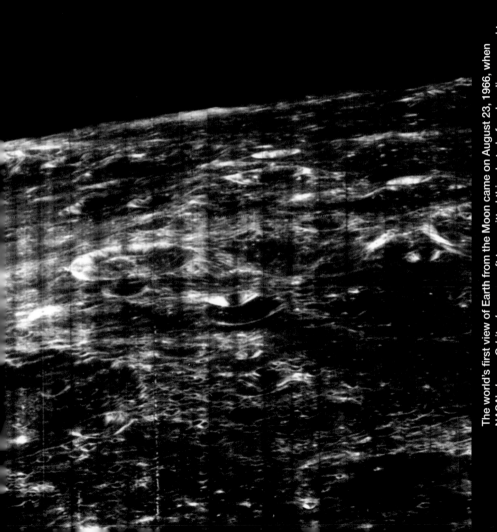

The world's first view of Earth from the Moon came on August 23, 1966, when NASA's *Lunar Orbiter I* spacecraft transmitted this photo before heading around to the dark side. Five unmanned lunar orbiters were launched in 1966–67 to map the lunar surface in preparation for the Apollo missions.

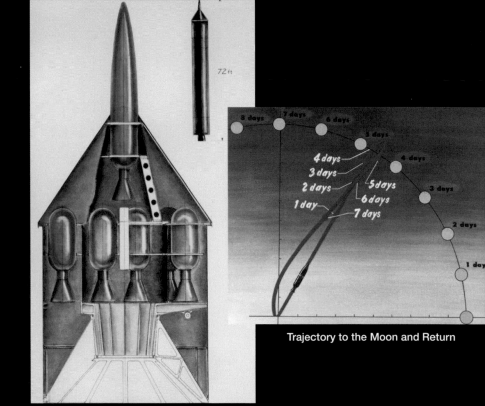

High-Speed Stages

Trajectory to the Moon and Return

Proposed at the Jet Propulsion Laboratory (JPL) in 1957 in response to the Sputnik program, Project Red Socks was to be "the world's first useful moon rocket." Nine missions were planned, with the second intended to send photos of the Moon. The idea did not receive much support, so JPL went on to work with the Army Ballistic Missile Agency on the *Explorer 1* satellite.

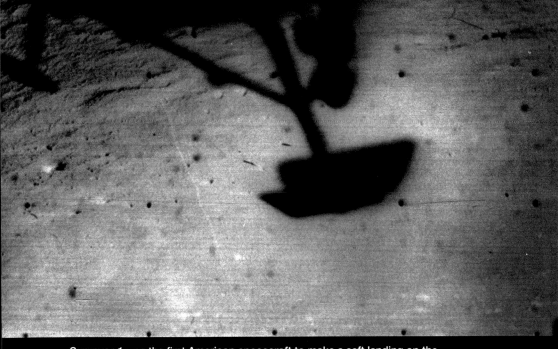

Surveyor 1 was the first American spacecraft to make a soft landing on the Moon. Launched on May 30 and arriving on June 2, 1996, *Surveyor* tested landing techniques that would eventually be used in the Apollo missions, while also studying the lunar soil, temperatures, and radar reflectivity.

169

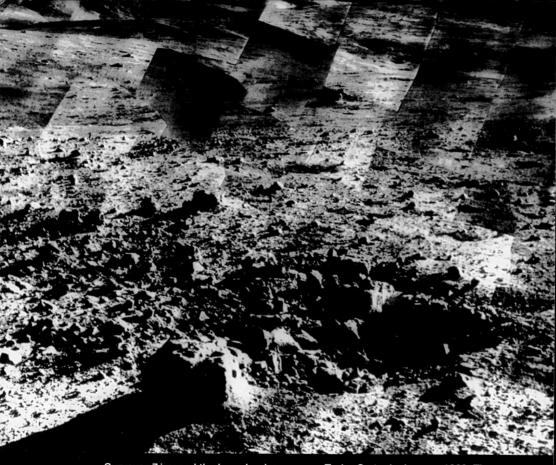

Surveyor 7 imaged the lunar landscape near Tycho Crater in January 1969. The rock in the foreground is a half-meter (1.5 feet) wide; the hills are 13 kilometers (8 miles) away.

→ The *Galileo* spacecraft—on its way to Jupiter in December 1992—looked back and caught this rare glimpse of Earth and the Moon in the same field of view. The image was taken from 6.2 million kilometers (3.9 million miles) away.

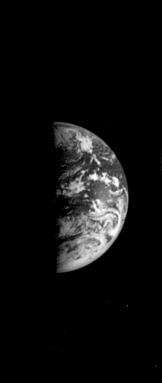

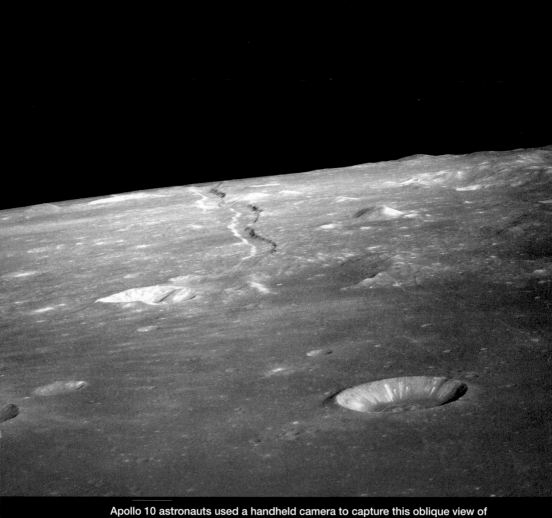

Apollo 10 astronauts used a handheld camera to capture this oblique view of
Rima Ariadaeus—a rille or riverlike feature near the lunar equator—in May 1969.

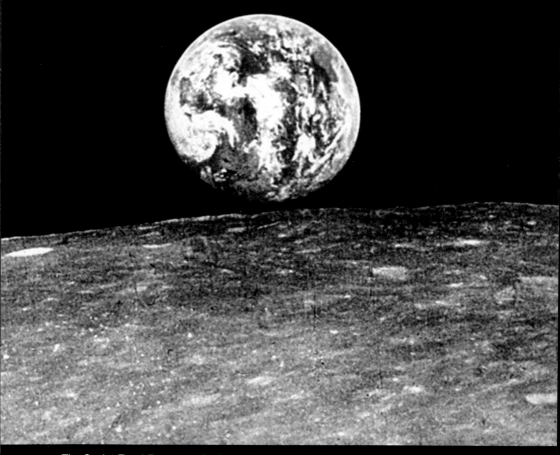

The Soviet *Zond-7* spacecraft glimpsed earthrise in August 1969.

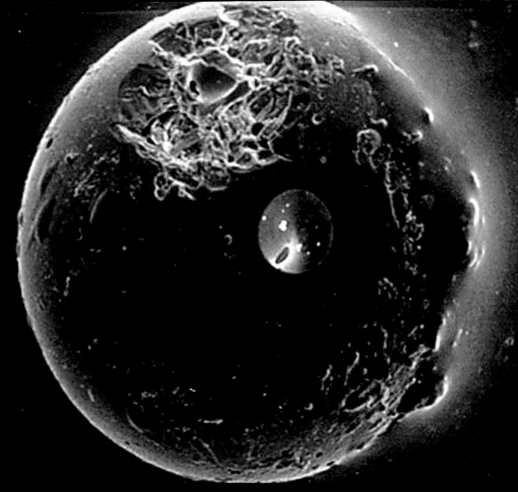

Formed by a meteorite impact on the Moon that splattered and melted rock, this microscopic sphere of glass was one of many found in lunar soils returned during the Apollo missions. This sphere is a quarter of a millimeter (a thousandth of an inch) across.

While collecting samples near the Taurus-Littrow landing site, Apollo astronauts Harrison Schmidt and Eugene Cernan noticed some unusual orange soil on the surface. Geologists have since analyzed it to find some of the smallest particles on the Moon, perhaps created by an explosive volcanic eruption and "fire fountain" some 3.6 billion years ago.

175

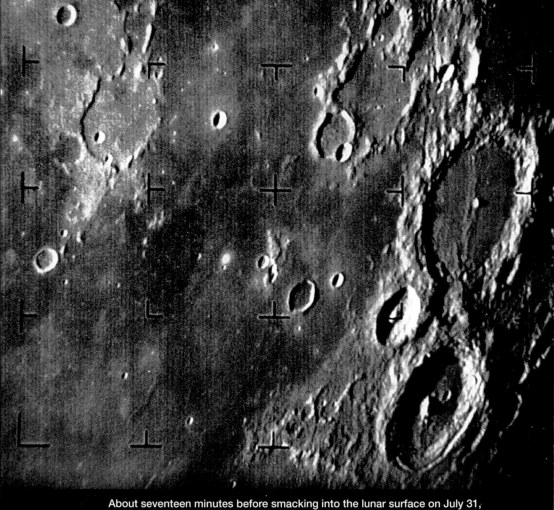

About seventeen minutes before smacking into the lunar surface on July 31, 1964, the *Ranger 7* spacecraft took the first photo of the Moon by a U.S. spacecraft. The large crater at the right is Alphonsus, with Ptolemaeus above it and Arzachel below.

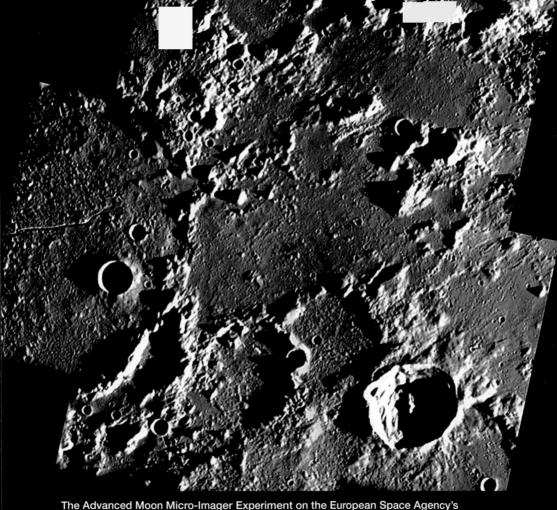

The Advanced Moon Micro-Imager Experiment on the European Space Agency's SMART-1 spacecraft collected this composite view of craters Bond and Mayer near Mare Frigoris in February 2006. SMART-1 was the first European mission to the Moon.

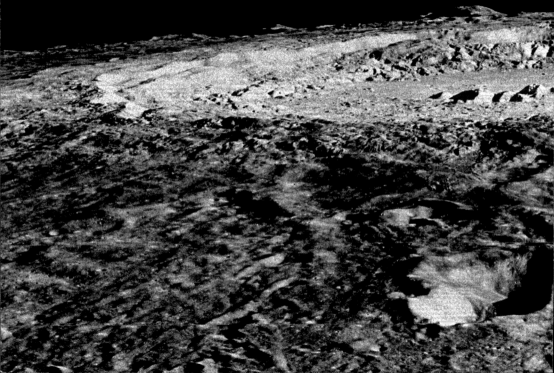

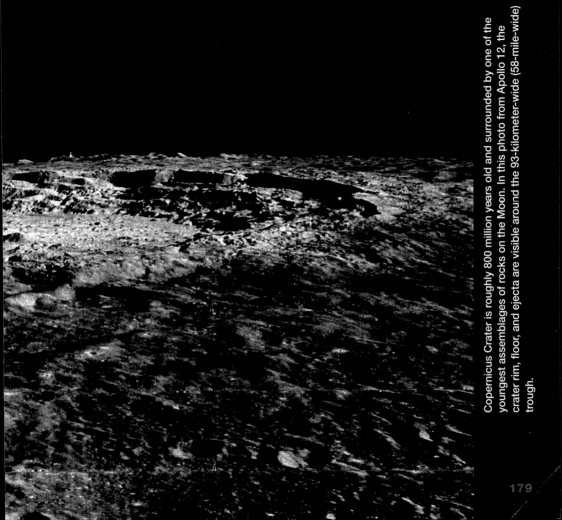

Copernicus Crater is roughly 800 million years old and surrounded by one of the youngest assemblages of rocks on the Moon. In this photo from Apollo 12, the crater rim, floor, and ejecta are visible around the 93-kilometer-wide (58-mile-wide) trough.

↑↑ The Hubble Space Telescope collected this closeup of the crater Copernicus and its terraced walls.

↑ Vallis Schroteri is the largest known sinuous rille on the Moon. Schroteri stretches nearly 160 kilometers long (100 miles), 11 kilometers (7 miles) wide, and 1 kilometer (0.6 miles) deep.

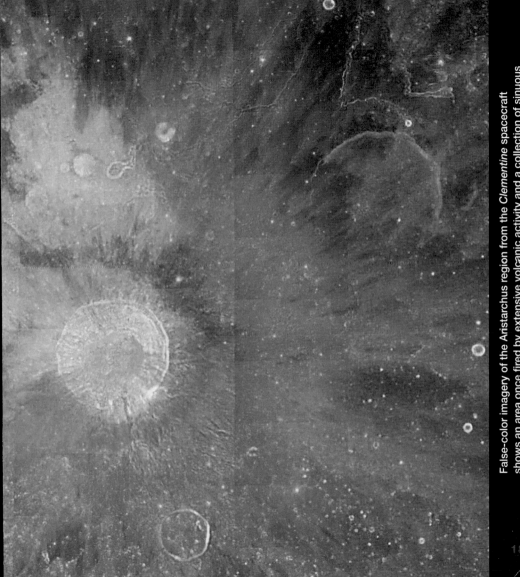

False-color imagery of the Aristarchus region from the *Clementine* spacecraft shows an area once fired by extensive volcanic activity and a collection of sinuous rilles (channels) clustered more densely than in any other part of the Moon.

183

The Men on the Moon

This is one small step for a man, one giant leap for mankind.

Neil Armstrong

It is estimated that one billion people watched Neil Armstrong and Buzz Aldrin take the first steps on the Moon.

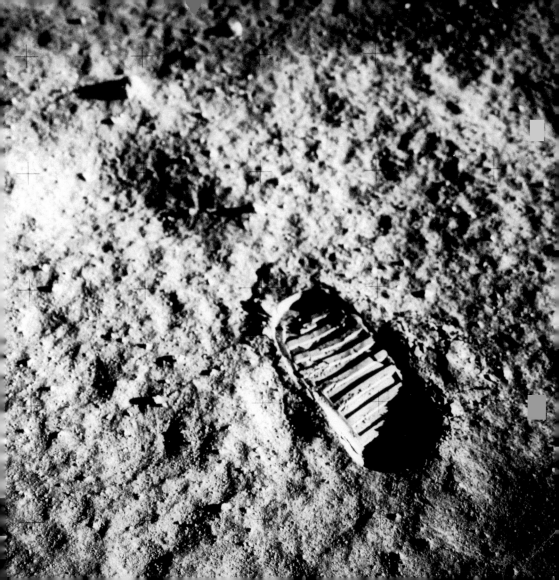

IT WAS THE GREATEST ADVENTURE IN HISTORY. LANDING HUMANS
on the Moon required more audacity, creativity, and sheer moxie on a scale
never before seen. The architects of the Space Race had to invent materials
and technologies that few had even imagined just a generation before. They
had to muster and organize nearly 400,000 people to build rockets, fly test
flights, produce PR films, design heat shields, install miles of cables and wires,
and sew space suits. They had to invest billions of dollars—$25 billion in 1969
dollars—to pursue a goal that many people inside and outside of NASA
weren't even sure was attainable. They had to take risks with the most
expensive currency: human lives.

"But why the moon? Why choose this as our goal?" said President John
F. Kennedy in a speech at Rice University in September 1962. "We choose
to go to the moon…and do the other things, not because they are easy, but
because they are hard, because that goal will serve to organize and measure
the best of our energies and skills, because that challenge is one that we are
willing to accept."

It took thousands of math equations to figure out how to get a moving
spacecraft to leave a moving planet to reach a moving Moon and return to a
moving planet—with gravity pulling on all three bodies at the same time. When
the Space Race started, calculations were done by slide rule; the *Apollo 11*
craft was guided by adolescent computers. By the time the Skylab space sta-
tion flew in the mid-1970s, the pocket calculators carried by astronauts had
more brain power than the computer that landed men on the Moon.

Science writer Andrew Chaikin claims that when it was first launched in
1967, the 111-meter (363-foot), 3-million-part *Saturn V* rocket was the most
powerful ever flown, with as much explosive energy as the atomic bomb. "The

Saturn V was NASA's answer to the Pyramids," Chaikin wrote. That rocket carried the astronauts from Earth to the Moon in 66 hours, about the same amount of time for an ocean liner to cross the Atlantic.

Most of us think of Neil Armstrong, Buzz Aldrin, and Michael Collins as the first Moon visitors, but that distinction belongs to the *Apollo 8* crew of Frank Borman, James Lovell, and William Anders. This trio made the first flight across the 386,000-kilometer (240,000-mile) gulf of space and orbited the Moon on December 24, 1968, seeing the "far side" for the first time with human eyes. On Christmas Eve, they famously read the creation passage from the *Book of Genesis* as they spoke to millions of people listening on TV and radio to the transmissions from their spacecraft.

It was another seven months before Armstrong and Aldrin made those first small steps on the surface of the Moon. *Apollo 11* launched on July 16, 1969, landed on July 20, and returned to Earth on July 24. Anywhere from 500 million to a billion people watched Armstrong's footfall at 10:56 p.m. Eastern Standard Time. In a whirlwind of 2.5 hours, the astronauts deployed a solar wind collector, a seismometer, a laser reflector, a flag, and a plaque proclaiming: "We came in peace for all mankind." They scooped up 47 pounds of rocks and took 166 pictures.

Over the next forty-two months, ten more men bounced on the lunar surface in spacesuits that provided oxygen, protected them from extreme heat and cold (from -100°C to +130°C), and shielded their bodies and eyes from solar radiation. They wore checklists sewn into the forearms of the suits, reminding them of the many tasks they were expected to jam into the precious little time they would have on the Moon. The Apollo 12 team had but 7.5 hours to work on the Moon; the Apollo 17 crew had 22 hours spread over three days.

The lack of air on the Moon, coupled with the diminished gravity—one-sixth the gravitational pull on Earth's surface—made every movement a novel experience. The astronauts reported jumping 3 or 4 feet above the surface with little effort. Apollo 15 astronaut Dave Scott wrote in 1972: "To fall on the Moon is to rediscover childhood."

On those six trips, the astronauts brought (and usually left behind) geological hammers, rakes, and samplers for collecting rocks and soil; seismometers for detecting moonquakes, meteorite impacts, and other jolts to the surface (nearly 12,000 events were recorded between 1969 and 1977); mirrorlike reflectors for a laser-ranging experiment (still ongoing) to measure the distance from the Moon to Earth; and solar wind detectors to measure the radiation impact of our nearest star. They brought golf clubs and balls, a javelin, and the greatest dune buggies of all time (the three lunar rovers). They brought flags, plaques, bibles, and family photos. Altogether, humans have left 170,000 kilograms (375,000 pounds) of earthly materials on the lunar surface, from Apollo equipment to unmanned lunar spacecraft that landed or were crashed into the surface.

About 382 kilograms (842 pounds) of rocks, pebbles, sediment cores, and soil were brought back from nine locations on the Moon by the Apollo astronauts and three Russian sample-return missions (Luna 16, 20, and 24 brought back about 0.3 kilograms). The youngest rocks turned out to be older than almost any on Earth, ranging from 3.2 to 4.6 billion years old and providing clues to conditions during the earliest days of our solar system. Those samples have fundamentally changed what scientists thought they knew about the geology of the Moon.

There is a colloquial saying among astronomy buffs that we are all made

of stardust. If that is true, then the Moon is made of Earth dust. With the rocks recovered during those heady missions—plus a fair amount of scientific theorizing, Earth-based fieldwork, and astronomical observations—scientists have surmised that the Moon was born 4.6 billion years ago out of a massive collision between the primordial Earth and a large asteroid or planetary object the size of Mars. Molten rock and other materials exploded from Earth into space, gradually coalescing and solidifying to form the Moon.

It makes sense that the Moon should have been born of the Earth, given how the Moon is so much a part of our life here.

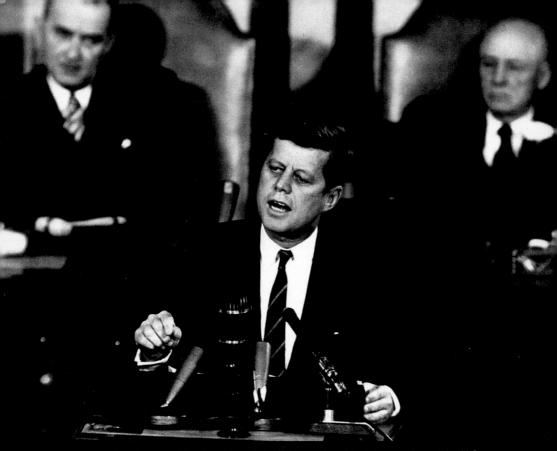

On May 25, 1961, President John F. Kennedy told a joint session of the U.S. Congress: "I believe this nation should commit itself to achieving the goal, before this decade is out, of landing a man on the Moon and returning him safely to the Earth." Vice President Lyndon Johnson (left) and Speaker of the House Sam Rayburn sit behind him.

→ The launch gantries on Missile Row at Cape Canaveral Air Force Station aimed toward their ultimate target in 1965.

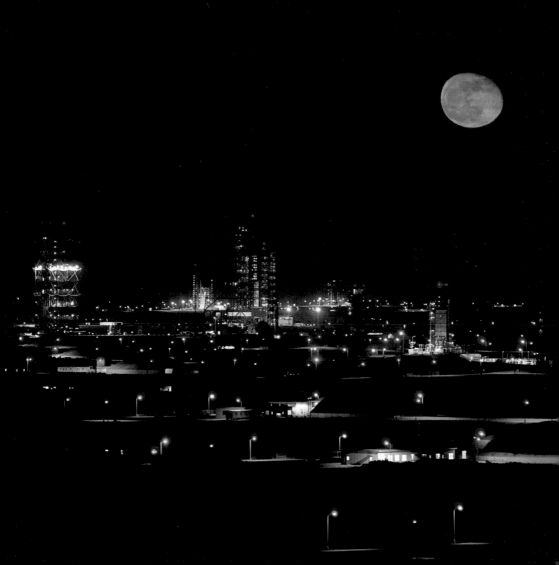

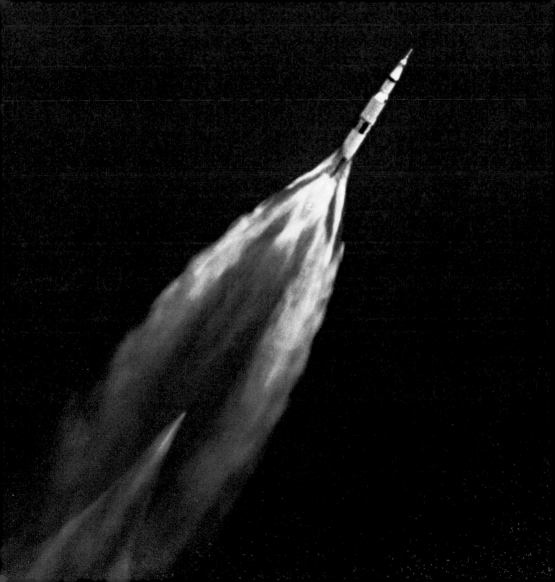

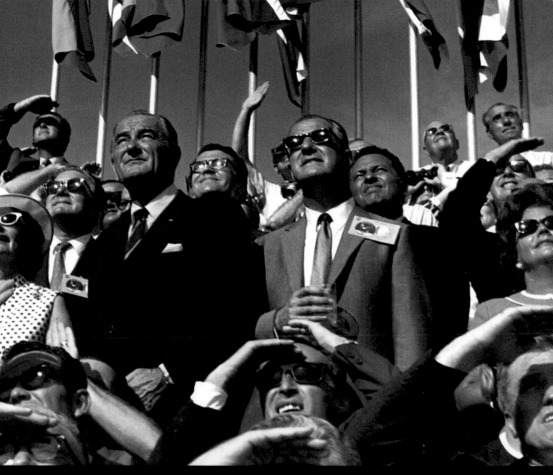

Former President Lyndon B. Johnson—who presided over much of the development of the Moon program—and Vice President Spiro Agnew join spectators watching the launch of Apollo 11 from Cape Canaveral (now Kennedy Space Center) at 9:32 a.m. Eastern Standard Time on July 16, 1969.

← The *Saturn V* rocket carrying the Apollo 11 astronauts climbs toward space.

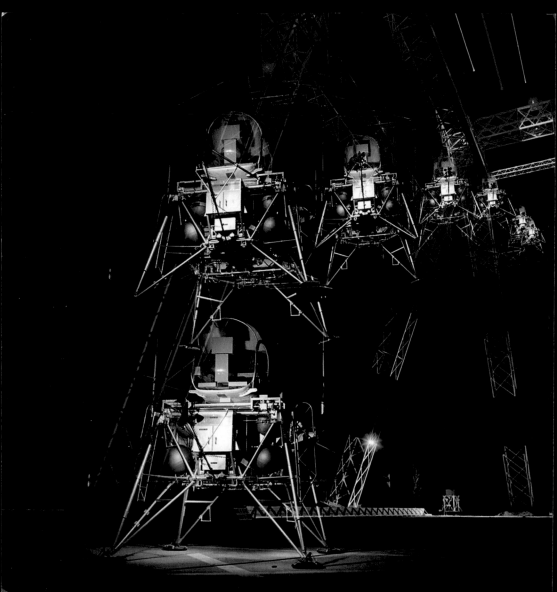

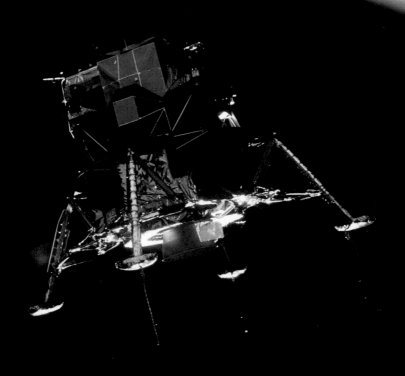

This view of the *Eagle* lunar module was shot after it separated from the command module *Columbia* on July 19, 1969. The long antennalike rods sticking out of the landing gear were sensing probes that, upon touching the surface, signaled to the crew to shut off the engines.

← Moon landings were simulated in a trainer at the Lunar Landing Research Facility at NASA's Langley Research Center in Virginia.

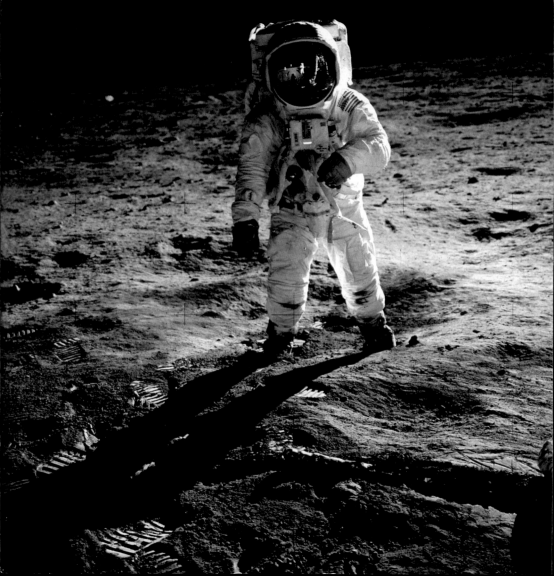

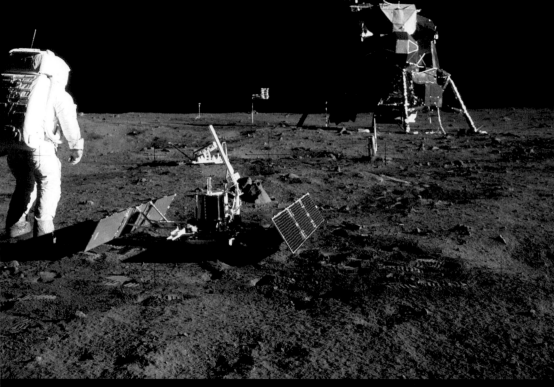

Buzz Aldrin stands next to a seismometer that he and Neil Armstrong deployed on the Moon, while looking back at the *Eagle*. Data retrieved from Apollo-era instruments revealed more than 12,000 detectable seismic "events"—everything from meteorites (and Apollo equipment) striking the surface to rock slides, tidal flexing of the crust, and moon quakes.

← Neil Armstrong captured Buzz Aldrin—and his own reflection—in this famous shot from the first two-and-a-half hours spent on the Moon.

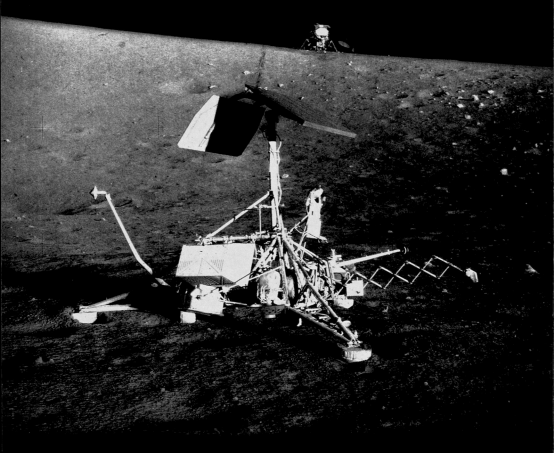

In November 1969, the *Apollo 12* lunar module (background) landed just 180 meters from the *Surveyor 3* spacecraft, which had arrived two-and-a-half years earlier. Astronauts Pete Conrad and Alan Bean removed some of the parts from the robotic spacecraft for return to Earth.

→ Command module astronaut Richard Gordon captured this view of the *Apollo 12* lunar module while it was roughly 110 kilometers above the surface.

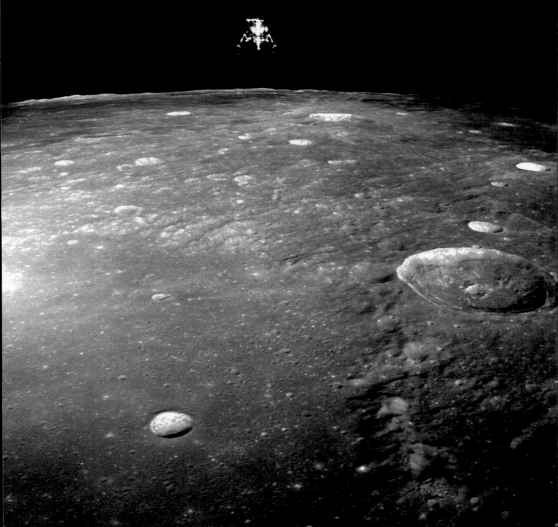

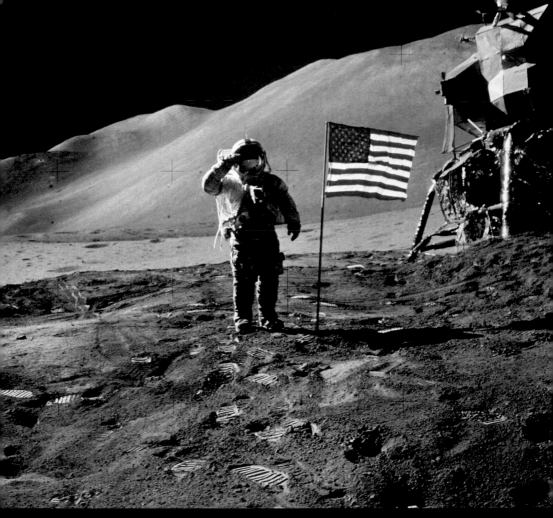

Apollo 15 astronaut Dave Scott—with the lunar module *Falcon* behind him—
salutes the American flag at the Hadley-Apennine lunar landing site.

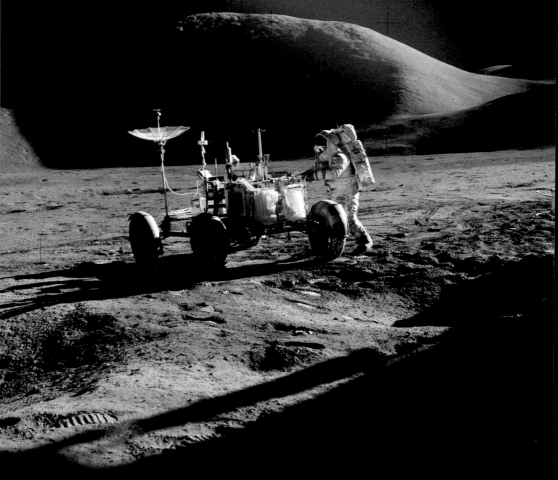

Lunar-module pilot James Irwin works near the lunar roving vehicle during the first extravehicular activity of the Apollo 15 mission. The shadow of the *Falcon* is in the foreground, while Mount Hadley looms in the background.

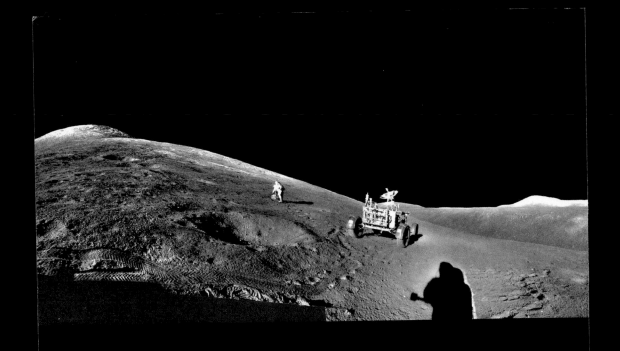

The Apollo 15 mission of 1971 was the first to deploy a lunar rover. Astronauts James Irwin and David Scott were charged with gathering samples and observations of various features of the lunar surface. Here, Scott examines a boulder in front of the Mount Hadley Delta.

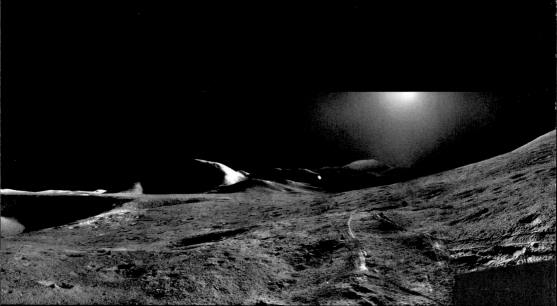

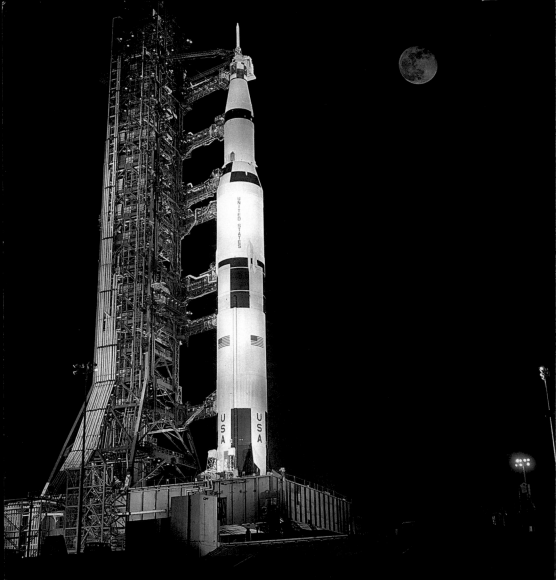

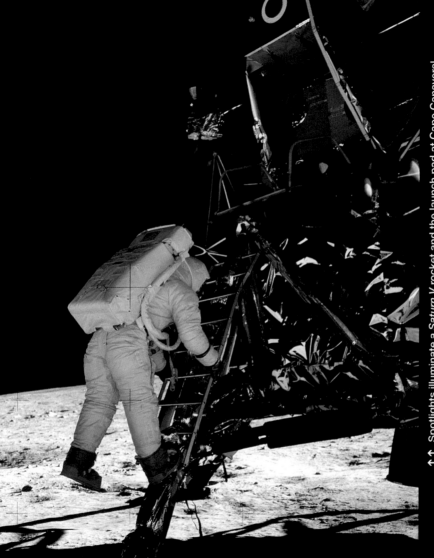

↑↑ Spotlights illuminate a *Saturn V* rocket and the launch pad at Cape Canaveral in December 1972. Apollo 17 was the last mission to land humans on the Moon.

↑ Astronaut Alan Bean—the fourth man on the Moon—descends from the lunar module on November 19, 1969. His photographer (and short-statured partner), astronaut Pete Conrad, allegedly said, "Man, that may have been a small one for Neil, but that's a long one for me!"

205

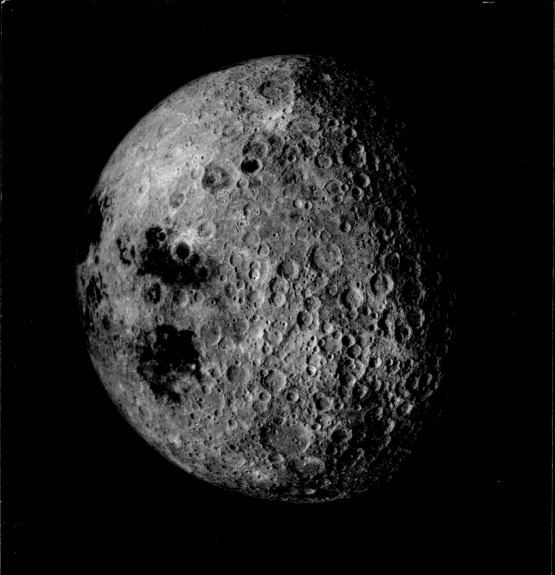

**HERE MAN COMPLETED HIS FIRST
EXPLORATIONS OF THE MOON
DECEMBER 1972, A.D.
MAY THE SPIRIT OF PEACE IN WHICH WE CAME
BE REFLECTED IN THE LIVES OF ALL MANKIND**

EUGENE A. CERNAN
ASTRONAUT

RONALD E. EVANS
ASTRONAUT

HARRISON H. SCHMITT
ASTRONAUT

RICHARD NIXON
PRESIDENT, UNITED STATES OF AMERICA

This is a copy of the stainless-steel plaque the Apollo 17 astronauts left at their Taurus-Littrow landing site on the last manned mission to the Moon.

← Apollo 16 astronauts captured this view of the eastern edge of the near side (left) and the heavily cratered far side.

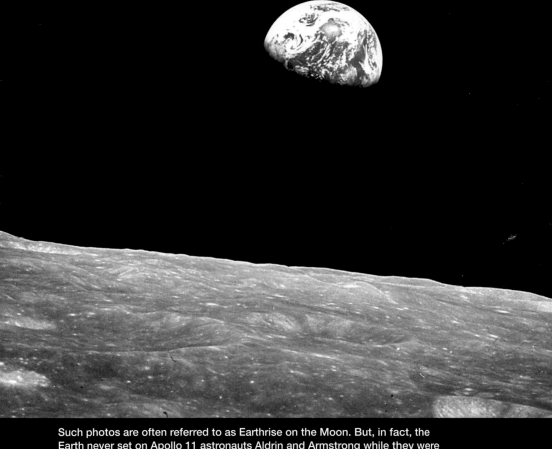

Such photos are often referred to as Earthrise on the Moon. But, in fact, the Earth never set on Apollo 11 astronauts Aldrin and Armstrong while they were on the surface of the Moon.

← A 6-inch-long golden olive branch—the international symbol of peace was left on the Moon by the Apollo 11 astronauts as a wish for peace for our planet.

Going Back and Going Beyond

I had the ambition not only to go farther than
man had gone before, but to go as far
as it was possible to go.

Captain James Cook

The icy moon Dione passes in front of Saturn and just above its rings, as viewed by the *Cassini* spacecraft in October 2005.

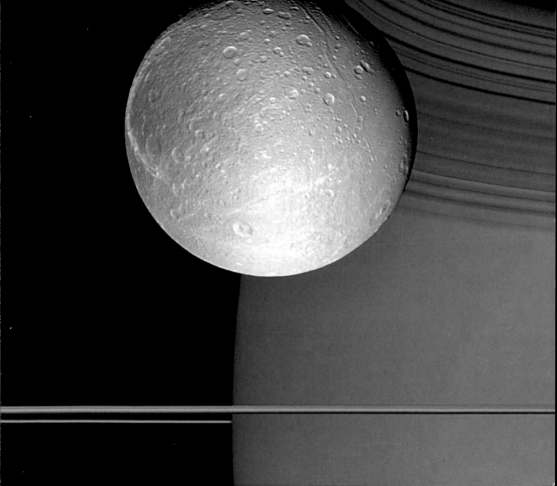

THOUGH OUR MOON IS THE MOST FAMILIAR AND DEAR TO US,
it is but one of many in the solar system. At least 165 natural satellites—
moons—orbit the eight planets and three dwarf planets, and that number
grows each year. Nine new moons of Saturn were announced in 2006,
and two new moons apiece were discovered around Pluto and Uranus in
2005. The number of moons rises higher when you add the 37 rocks orbiting
asteroids, such as Dactyl, which was discovered in 1993 to be orbiting
asteroid Ida.

Four of the moons in our solar system—Ganymede, Titan, Callisto, and
Io—are larger than Earth's Moon. A few moons have atmospheres (mostly
tenuous), and a few more have water, or at least ice. Some formed from the
same planetary disk that spawned their patron planets, while others seem to
be space debris that became caught up in the gravity of one planet or another.

Mercury and Venus do not have moons, while Mars has two—the smallest
in the solar system. Phobos and Deimos are believed to be captured aster-
oids. Phobos orbits less than 6,000 kilometers (3,700 miles) from the Martian
surface, the closest approach of any moon to its home planet. Researchers
expect Phobos to crash into the planet or break up in about 50 million years.

Jupiter has been surveyed by seven spacecraft and has revealed at least
63 moons, though none are as impressive as the original four satellites—Io,
Europa, Ganymede, and Callisto—discovered by Galileo in 1609. Io is home
to hundreds of active volcanoes. Pushed and pulled in an intense tug of war
with Jupiter that flexes and squeezes the moon's innards, Io spews a mixture
of sulfur, sulfur dioxide, and molten rock that constantly remakes its surface.
Callisto, on the other hand, is the most cratered body in the solar system. Its
surface is extremely old, barely changing in the past 4 billion years.

Ganymede is the largest moon in the solar system, and it is significantly larger than even Mercury or Pluto. The surface crust of this satellite appears to be covered in ice, but beneath lies a molten iron core; a rocky, silicate mantle; and signs of plate tectonics—perhaps making it more Earthlike in its geology than any other solar-system body.

Europa is perhaps the most intriguing moon in the solar system. Covered with an outer shell that looks remarkably like earthly sea ice, Europa is believed to hide an ocean of water. The moon's surface is scarred with cracks and creases, but very few craters—signs that the surface is changing regularly, perhaps through the melting and freezing of the ice. Europa's ice and ocean, some believe, could be an incubator for life.

Saturn, which is currently being surveyed by the Cassini mission, holds court with 56 moons. Its moon Titan competes with Europa for the title of most tantalizing to scientists looking for life-supporting possibilities. Like Ganymede, Titan measures larger than two planets, and its surface is shrouded in a dense atmosphere of nitrogen, argon, and methane. The atmospheric pressure is not too different from Earth's (about 50 percent higher), and the breakup of methane by sunlight produces a thick smog. Some researchers see parallels to the primordial Earth in Titan's atmosphere. Of the remaining planets and dwarf planets, Uranus has 27 moons, Neptune 13, Pluto 3, and Eris one. The most interesting body is Triton (satellite of Neptune), the only large moon with a retrograde or "backward" orbit.

As we turn our astronomical eyes beyond the solar system and hunt for extrasolar planets—that is, planets orbiting other stars—we are likely to find extrasolar moons with ever more interesting profiles. But before we go farther in our exploration, some say we ought to go back to the Moon and restart the

journey that ended so abruptly three decades ago. That sentiment appears to be catching on around the world.

The Japan Aerospace Exploration Agency (JAXA) is preparing the *Selene* orbiter for a launch in 2007, calling it the largest lunar mission since Apollo. Another Japanese craft known as *Lunar A* may go up as soon as 2010. The Indian Space Research Organization (ISRO) has plans to launch that nation's first lunar expedition. The *Chandrayaan-1* lunar orbiter—Hindi for "Moon Craft"—could lift off as soon as 2008. *Chang'e 1*, proposed for launch in 2007 or 2008, is China's entry into the new race for the Moon. And the Russian rocketry company, Energia, has been making its own plans to go back to the Moon, either on its own or with an international partner. The Indians and Chinese have pledged to put humans on the Moon by 2030, the Japanese by 2020.

The U.S. National Aeronautics and Space Administration (NASA) has offered the most comprehensive plan for returning humans to the Moon. The Lunar Reconnaissance Orbiter is being scheduled for launch in 2008, the first of a series of robotic probes designed to find landing sites and resources. The proposed Moonrise mission could return lunar samples from the lunar south pole, perhaps discovering whether there is useful water-ice on the Moon. And the centerpiece is the Orion program, which will build on Apollo-era designs to create the next generation of Moon rockets, command modules, and landing craft. The plan calls for manned space flights in new vehicles by 2014 and a new landing on the Moon by 2020.

Before anyone can settle in for a long stay on the Moon, some critical technical problems need to be solved. The extreme heat and cold, not to mention the extremes of light and dark, pose interesting design questions for lunar architects. Supplying a lunar outpost will require the invention of new life-sup-

port technologies and the harvesting of unusual resources—space-grown food; soil-harvested, breathable oxygen; and hydrogen for fuel—because only so much can be carried on a few rockets.

Solar radiation and cosmic rays are intense on the lunar surface due to the lack of atmosphere, and some physicists have speculated that Apollo astronauts might have died from radiation sickness if they had been on the Moon during a dramatic August 1972 solar flare and storm. The dust on the Moon will pose challenges, as it is so fine that it becomes embedded in everything it touches (including air filters and circuitry). Someone even need to consider how to preserve the mental health of astronauts living in confined spaces and unusual environments for periods longer than anyone has endured in a space station.

Then there are the political and philosophical questions lurking on the dark side. If there was a blessing that came out of the Cold War, it's that the United States and Russia pushed themselves to their competitive limits while keeping that exploration peaceful. Though there are patriotic symbols left in the regolith, no one has claimed the Moon for themselves.

But will that precedent hold? Will we return to the Moon and stake claims, like so many colonial powers carving up empires? Or will we leave it as a shared protectorate for all of humanity, a sort of cosmic Antarctica with base camps for cooperative science and exploration?

Much will be different the next time humans land on the Moon. Women will be part of the crews; the pace of exploration will likely be slower but steadier; and the space ships will no longer be making voyages of discovery.

But there will be no shortage of people who'd like to go. "Nothing will stop us," said Yuri Gagarin in 1967. "The road to the stars is steep and dangerous. But we are not afraid."

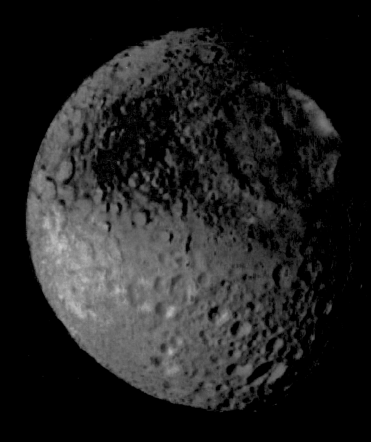

Saturn's moon Mimas, shown here in false color, is noteworthy for the Herschel Crater that spans nearly one-third of its surface. Herschel is 10 kilometers (6.2 miles) deep, with a mountain near the center that is nearly as high as Mount Everest.

The Huygens probe—built by the European Space Agency—was designed to get a close-up of Saturn's most famous moon. This composite view of Titan's surface from an altitude of about 10 kilometers (6.2 miles) was collected on January 14, 2005, as the probe headed toward its impact on the surface.

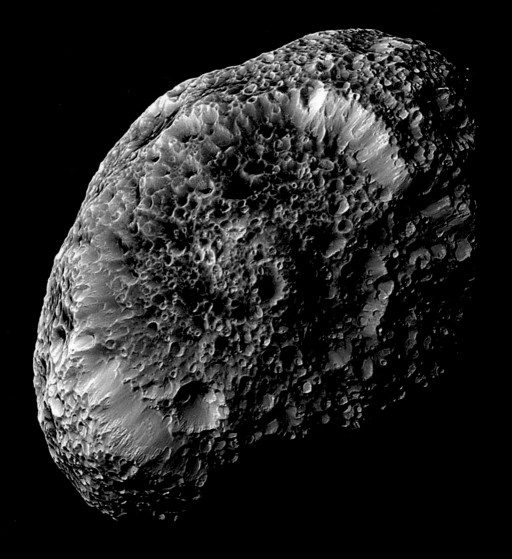

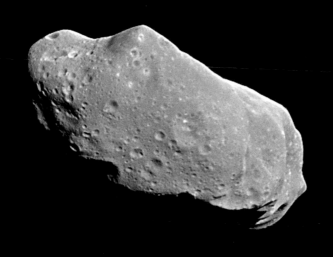

Asteroid Ida, found in the belt of orbiting rocks between Earth and Mars, was the first to be found with its own moon. Dactyl was discovered in 1994 when the *Galileo* spacecraft flew past.

← Saturn's moon Hyperion has a pockmarked, spongelike texture due to thousands of craters. The moon is roughly 250 kilometers (155 miles) across and may house a vast system of caverns inside.

219

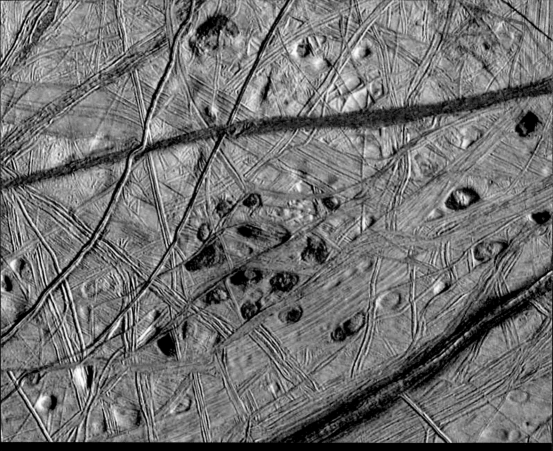

Jupiter's moon Europa is completely covered in ice, which scientists believe covers a vast ocean. The fault lines and cracks reveal how pieces of this icy crust slide past each other, while dark material in the cracks suggests that the ice might occasionally melt and let fluid from the interior leak out onto the surface.

→ Volcanoes constantly erupt on Jupiter's moon Io, as shown here by the *Galileo* spacecraft in February 2000. Lava glows near an active flow (at left), while the surrounding surface is covered in sulfur and silicate rock.

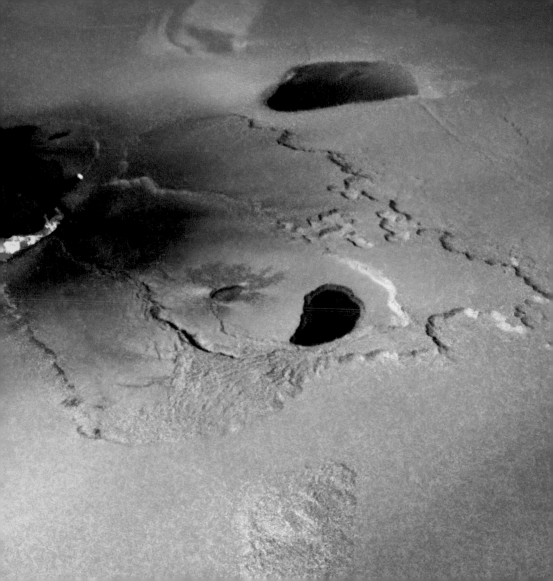

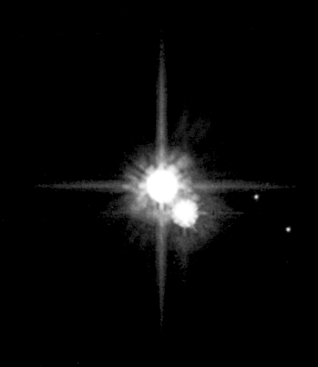

Pluto, recently demoted from its status as a planet, has three moons. Nix and Hydra were discovered in 2005 by the Hubble Space Telescope; Charon (closest to the center) was discovered in 1978.

➔ In 2004, the Hubble telescope spied five spots on Jupiter—three dark and two light. Jupiter's moon Io is the white circle in the center of the image, with its dark shadow falling to the left of it. Ganymede is the blue circle in the upper right, with its shadow trailing on the far left. Callisto is out of the field of view, but its shadow falls in the upper-right side of this view.

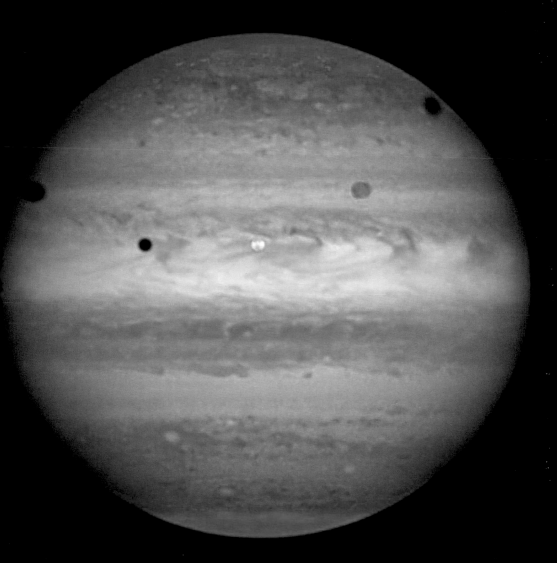

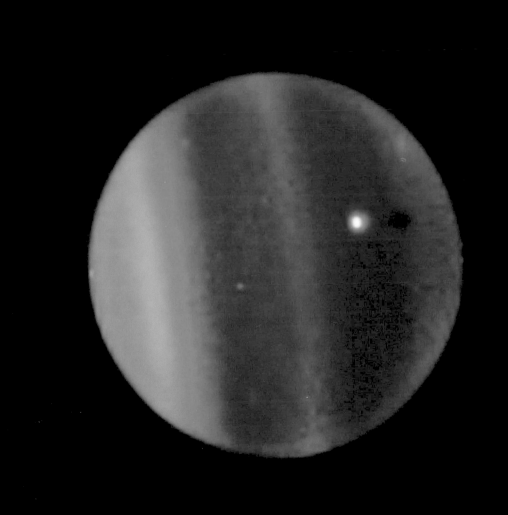

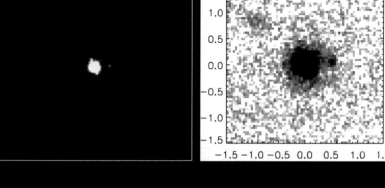

In September 2005, astronomers using ground-based, infrared telescopes detected a moon—Dysnomia (smaller dot at 3 o'clock)—orbiting Eris (larger, center orb), a planet-like object outside the orbit of Pluto. Eris was briefly considered our solar system's tenth planet, until Pluto, Eris, and similar objects were reclassified. The above left image is a colored version of the raw (above right) original.

← The 1,100-kilometer-wide (684-mile-wide) moon Ariel (green-white dot) and its shadow make a transit across the face of Uranus, as spied by the Hubble Space Telescope. Such an eclipse is particularly rare (and the first ever detected from Earth) because the planet's axis is tipped on its side compared to the plane of the planets and only half of its face (from our view) is usually in sunlight.

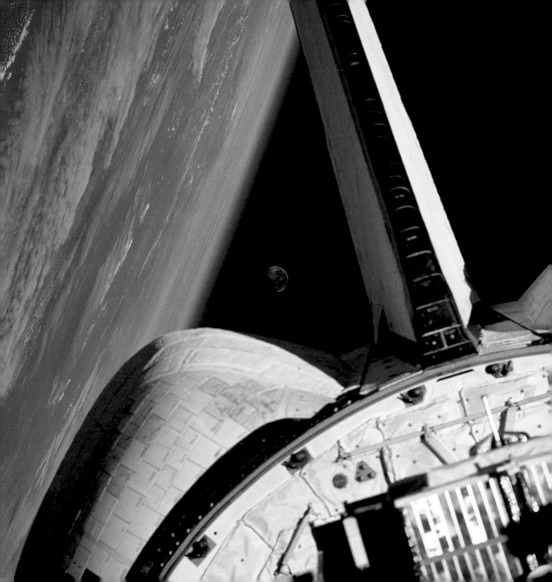

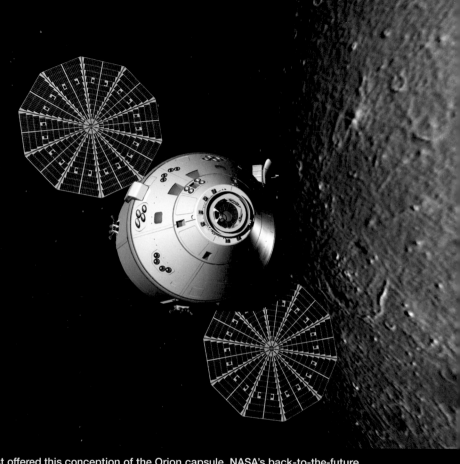

An artist offered this conception of the Orion capsule, NASA's back-to-the-future plan to return to the Moon by 2020. The first Orion flights are planned to take off by 2014, with vehicles built to accommodate up to six astronauts.

← Astronauts on space shuttle *Discovery* caught this view of the Moon framed between their spacecraft and the Atlantic Ocean in November 1998.

Aldebaran

Phobos

Deimos

Spirit Sol 594
September 4, 2005
Time lapse from 150 sec. time intervals

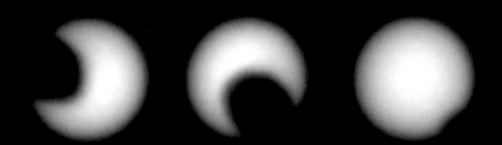

↑↑ From its vantage point in Gusev Crater on the Martian surface, the *Spirit* rover captured this view of the two moons of Mars—Phobos and Deimos—rising into the night sky.

↑ The moon Phobos makes a partial eclipse of the Sun, as viewed from the surface of Mars by NASA's *Opportunity* rover.

Phobos is the innermost and larger of Mars's two moons. In this view from the *Mars Global Surveyor* spacecraft, a 10-kilometer (6-mile) impact crater known as Stickney is half as wide as the moon itself.

229

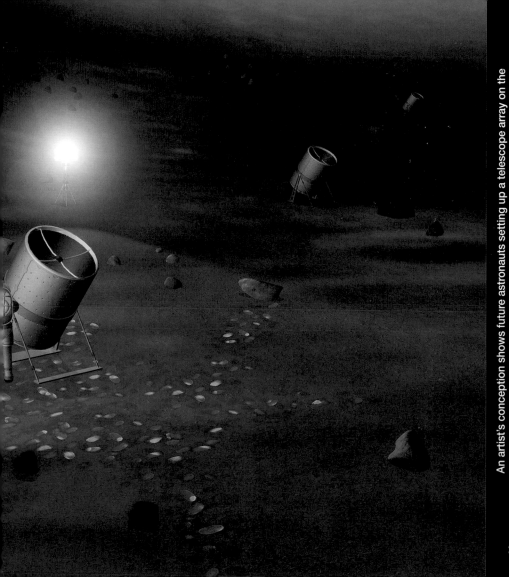

An artist's conception shows future astronauts setting up a telescope array on the surface of the Moon. With no atmosphere to distort the viewing, ground-based astronomy could be much easier (or at least clearer) on the Moon.

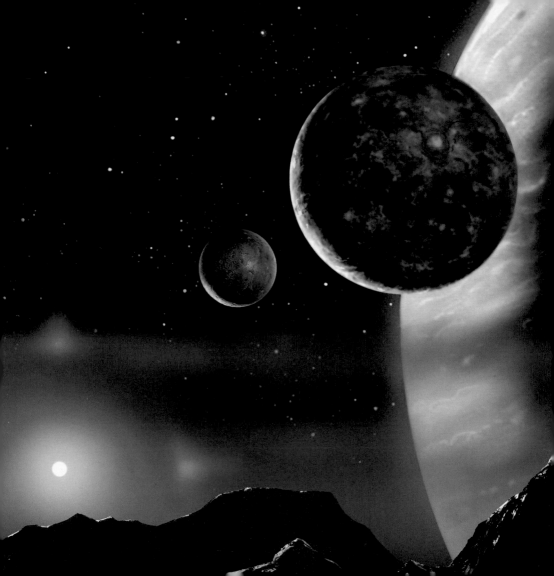

Are there moons beyond our solar system? Logic and science suggest that there are. One artist offered this concept of what the sky might look like from the surface of a moon orbiting the Jupiter-like planet discovered around star HD70642.

HARDY

233

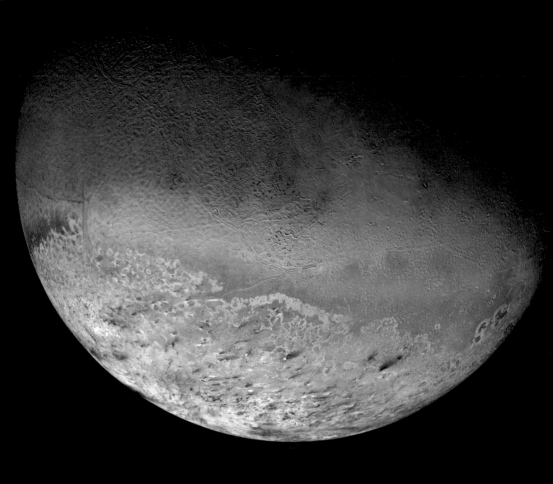

Neptune's moon Triton was imaged in 1989 by the *Voyager 2* spacecraft. It is one of three objects in the solar system—including Earth and Saturn's moon Titan—known to have a nitrogen-dominated atmosphere.

In Print

Michael Light. *Full Moon*. (New York: Knopf, 1999).

Jim Lovell and Jeffrey Kluger. *Lost Moon: The Perilous Voyage of Apollo 13*. (New York: Houghton Mifflin, 1994).

Stephen P. Maran. *Astronomy for Dummies*. (Foster City, Calif.: IDG Books, 2000).

Charles A. Wood. *The Modern Moon: A Personal View*. (Cambridge, Mass.: Sky Publishing, 2004).

On the Web

Carlowicz's Place in the Sun
www.stormsfromthesun.net

Dan Bush's Missouri Skies
www.missouriskies.org

Astrophotography by Anthony Ayiomamitis
www.perseus.gr

Shaun Lowe Photography
www.shaunlowe.com

Dennis Mammana Skyscapes
www.dennismammana.com

Astronomy Picture of the Day
http://antwrp.gsfc.nasa.gov/apod

Les Cowley's Atmospheric Optics
www.atoptics.co.uk

NASA Moon Gallery
http://nssdc.gsfc.nasa.gov/imgcat/html/group_page/EM.html

Starry Night Photography
www.southernskyphoto.com

Chris Linder Photography
www.chrislinder.com

Lauri Kangas Photography
www.photon-echoes.com

Lunar Photo of the Day
www.lpod.org

Views of the Solar System
www.solarviews.com

The Nine Planets
www.nineplanets.org

Photo Credits

Anthony Ayiomamitis: pages 47, 85, 105, 130, jacket front cover
Berkeley Geochronology Center/Lawrence Berkeley Laboratory: page 174
Marc-Andre Besel: page 118
Erwin Böhm, Mainz: page 56
Brown University/Lunar and Planetary Institute: page 20
M.E. Brown/W.M. Keck Observatory: page 225
Dan Bush: pages 15, 36, 37, 93, jacket back cover
John Caldwell/Alex Storrs/NASA: page 180
Andrew Carlowicz Sr.: page 240
Susan Carlowicz: page 57
Case Western Reserve University/NSF/NASA: page 132, 133
Chattanooga Bakery, Inc.: page 74
Chung Young Yang Embroidery Museum at the Sookmyung Women's University, Korea: page 82
Evad Damast: page 14
DCATT Team/MSX Project/BMDO: page 104
Jacques Descloitres, MODIS Rapid Response Team, NASA/GSFC: page 135
James DeYoung: page 69
Russell L. Doescher: page 110–11, endpapers
Steve Dutch: page 120
European Space Agency/NASA/JPL/ University of Arizona: page 217
European Space Agency/Space-X Space Exploration Institute: page 177
Andris and Dace Frievalds: page 33
Goodnight Moon © 1947 by Harper & Row. Illustrations © renewed 1975 by Edith Hurd, Clement
Hurd, John Thacher Hurd and George Hellyer, as Trustees of the Edith & Clement Hurd 1982 Trust. Used by permission of HarperCollins Publishers: page 76
Gorgo/Wikipedia Commons: page 59
Jens Hackman: page 90
David A. Hardy (astroart.org)/Particle Physics and Astronomy Research Council: page 232–33
Harvard College Observatory: page 124
iStockphoto.com/ronen: page 75

Lauri Kangas: pages 17, 108
William Keel: page 80
Pete Lawrence: page 126
Gain Lee: page 140
Erich Lessing/Art Resource, NY: pages 68, 77
Chris Linder Photography: pages 27, 35
Lockheed Martin Corp.: page 227
Shaun Lowe Photography: pages 2–3, 18, 19, 38, 39, 66, 100, 142, 143, jacket spine
C.R.Lynds, KPNO/NOAO/NSF: page 125
Malin Space Science Systems/NASA: page 229
Dennis Mammana, pages 34, 40, 45, 61, 96, 101, 109, 134, 138
Larry Mendenhall: page 41
Kay Meyer: pages 102, 103
MGM/Photofest: page 73
The Minneapolis Institute of Arts, The Putnam Dana McMillan Fund: page 63
NASA: pages 4–5, 7, 22, 23, 25, 32, 42, 54–55, 97, 145, 156, 157, 159, 162, 163, 166–67, 172, 175, 176, 185, 190–201, 204–209, 226, 230–31
NASA/ESA/E. Karkoschka page 223
NASA/ESA/L. Sromovsky/H. Hammel/K. Rages: page 224
NASA/ESA/H. Weaver/A. Stern/HST Pluto Companion Search Team: page 222
NASA/Jet Propulsion Laboratory (JPL): pages 158, 168-171, 219
NASA/JPL/Arizona State University: page 164
NASA/JPL/Cornell: page 228
NASA/JPL/Cornell/Texas A&M: page 228
NASA/JPL/Space Science Institute: pages 10, 211, 216, 218
NASA/JPL/University of Arizona: pages 11, 13, 221
NASA/JPL/University of Arizona/University of Colorado: page 220
National Park Service: page 52–53
Naval Research Laboratory/BMDO/USGS/ LLNL pages 12, 161
National Oceanic and Atmospheric Administration Library/NOAA Corps: pages 43, 79, 95, 123
Newark Earthworks Initiative/Ohio State

University: page 64
Christopher Palmer/Fairmount Park Commission: page 67
Pekka Parviainen: pages 99, 119, 136
The Philadelphia Museum of Art/Art Resource, NY: page 62
Don Petit/NASA: page 98
Chris Picking: pages 91, 113, 137
The Pierpont Morgan Library/Art Resource, NY: page 71
Vladimir Pomortsev/Dreamstime: page 60
Procter & Gamble: page 70
Rare Books Division, Special Collections, J. Willard Marriott Library, University of Utah: page 65
T.A. Rector, I.P. Dell'Antonio/NOAO/AURA/ NSF: page 1
Roberto Reid: page 44
Rice University/Galileo Project: page 121, 122
J. Schmitt et al./ROSAT Mission/MPE/ESA: page 107
Stefan Seip: page 139
Smithsonian Institution Libraries: page 24
Snark/Art Resource, NY: page 83
Soviet Lunar Program and NASA Space Science Data Center: pages 160, 173
Star Film/Edison Manufacturing Company/ Photofest: page 72
Philip Stooke, University of Western Ontario: page 120
D. Thompson et al./EGRET/Compton Observatory/NASA: page 106
Michel Tournay: pages 92, 94
Joe Tucciarone: page 131
Dan Wallace/Dreamstime: page 58
Mike Wirths: page 127, 128–29
U.S. Geological Survey/NASA: pages 16, 178–79, 202–03, 234
U.S. Geological Survey/NASA/JPL: page 21
U.S. Geological Survey/NRL/BMDO/LLNL, pages 150–154, 165, 181, 182–83, binding case
United States Postal Service. All Rights Reserved in "First Man on Moon" stamp image. Used with Permission: page 81
Patrick Zephyr Nature Photography: page 78

I was still growing in my mother's womb when Neil Armstrong and Buzz Aldrin first stepped onto the lunar surface; I would arrive on Earth about two weeks after they got back home. I have tried to convince my parents, long after the fact, that they must have named me Michael because they had to sit around and wait for me (30 hours of labor), just as Michael Collins had to wait anxiously for 27 hours, 51 minutes for his comrades to re-join him in lunar orbit.

I owe gratitude and intellectual debts to many people for the contents of this book. Thanks must start with Phil "The Bad Astronomer" Plait, for getting this project started and passing the baton to me, and to literary agent Skip Barker for another good pitch. I owe a huge debt to the many photographers who have been so generous with their work—most of all Dan Bush, Dennis Mammana, Anthony Ayiomamitis, Shaun Lowe, and Lauri Kangas.

The various space agencies and institutions, particularly NASA, deserve appreciation for remembering their most important constituents—the taxpayers—and making so much space information and imagery readily available. I am especially grateful to the many public information officers and science writers at NASA, NOAA, ESA, USGS, and other institutions, who work quietly and without attribution to provide invaluable reams of compelling and useful information. Thanks, too, to Calvin Hamilton, Bill Arnett, Les Cowley, Robert Nemiroff, Jerry Bonnell, the Windows to the Universe team, Dave Williams, and Jay Friedlander, who have put together incredible web-based resources.

I am in debt to Andrea Danese and Laura Tam for their invaluable editorial guidance and incredible patience with this project; thanks, too, go to Darilyn Carnes and E. Y. Lee for another book well designed.

Finally, I must acknowledge Mom and Dad, as well as Florence and the kids, who some-how manage to hold down the family fort while I try to keep a day job and then come home to write at night.

Editor: Andrea Danese
Designer: Darilyn Lowe Carnes with E.Y. Lee
Production Manager: Alison Gervais

Library of Congress Cataloging-in-Publication Data

Carlowicz, Michael J.
 The moon / Michael Carlowicz.
 p. cm.
 Includes index.
 ISBN 13: 978-0-8109-9307-5
 ISBN 10: 0-8109-9307-4
 1. Moon. I. Title.

 QB581.C37 2007
 523.3—dc22
 2006102611

Printed and bound in China
10 9 8 7 6 5 4 3 2 1

HNA
harry n. abrams, inc.
a subsidiary of La Martinière Groupe

115 West 18th Street
New York, NY 10011
www.hnabooks.com

Page 1
Using two telescopes and accompanying
CCD cameras at the Kitt Peak National
Observatory, astronomers collected
several images simultaneously to show the
Moon in its background of stars.

Pages 2–3
The waning crescent Moon awaits sunrise
along the frozen coastline of Dartmouth,
Nova Scotia.

Pages 4–5
The Moon sets over Earth's limb, as
viewed by the astronauts of space shuttle
Discovery during the STS-70 mission in
July 1995.

Below
The Carlowicz household in New Jersey,
where this snapshot of the broadcast of
the Apollo 11 Moon landing was captured.